D1081900

IMAGES
of America

LOUISVILLE'S
FERN CREEK

IMAGES
of America

LOUISVILLE'S
FERN CREEK

Cheryl Brandreth and Geoffrey Long Brandreth

ARCADIA
PUBLISHING

Published by Arcadia Publishing
Charleston, South Carolina

Printed in the United States of America

Library of Congress Control Number: 2015935774

For all general information, please contact Arcadia Publishing:
Telephone 843-853-2070
Fax 843-853-0044
E-mail sales@arcadiapublishing.com
For customer service and orders:
Toll-Free 1-888-313-2665

Visit us on the Internet at www.arcadiapublishing.com

*To the descendants of Dennis Long. May they
continue his legacy of integrity and hard work.*

CONTENTS

ACKNOWLEDGMENTS

The Kentucky Heritage Council has been in place since 1966. Since that time, over 90,000 sites have been surveyed and the Kentucky Historic Resources Inventory files are maintained at the Kentucky Heritage Council's office in Frankfort. We wish to thank all the researchers who have contributed to the files and the staff for their work in maintaining them, specifically Marty Perry for his invaluable help.

We wish to thank the many people who listened to our requests and contributed photographs: Bonnie H. Fritschner, Hon. George Long, William Nold, Pamela Gregory, Corrinne Nold, Jack Ridge, Carol Daugherty, Lenora Roberts, Father Dale Cieslik, Rev. Linda Barnes Popham, Joy Stelly, Cheryl Markley, Pastor Kerri McFarland, Kathy Fraley, Joey Bailey, Mary Margaret Bell, Capt. Mike Schmidt, and Steve Roberts.

INTRODUCTION

Louisville's Fern Creek community is named after the creek that meanders through the area. The signs of progress along Bardstown Road in Fern Creek give no indication that the original road was carved by buffalo following a trail of water from the Ohio River to Salt River in Bullitt County. The original settlers of Fern Creek, Guthrie, Sheppard, and Shaffer were given land grants in the 1780s when the road was still nothing more than a trail.

In an effort to connect large centers of trade, the state of Kentucky commissioned the Bardstown-Louisville Turnpike Company to construct a toll road connecting those two towns. A tollgate was erected in Fern Creek upon completion of the road in 1838. Stagecoaches ran along the route until they were replaced by later modes of transportation.

The construction of the Louisville-Bardstown Turnpike encouraged Fern Creek's growth, as farmers settled the land along the route, giving Fern Creek the name of Stringtown. The abundance of water sources in southeastern Jefferson County made it fertile ground for agriculture. Fern Creek was home to several farms, fruit orchards, and eventually, the Farmers and Fruit Growers Association, the Fern Creek Fair, and the Jefferson County Fair Company.

The rapidly growing transportation industry brought alterations to major roads like Bardstown Pike. In 1908, the Louisville and Interurban Railroad Company began a rail line to Fern Creek, where a terminal and a freight house were constructed. The rail service attracted developers, city dwellers, and eventually, suburban settlement. The Bardstown Pike was paved in 1922, encouraging further progress.

Improved transportation encouraged the first suburban development, and these large land tracts were divided for farms and other agricultural purposes, and later for residential use. Fern Creek has always been rich in natural resources, but the land had potential for further development given its strategic location along a major transportation route.

World War II brought significant changes to Jefferson County. Standiford Field opened as a commercial airport in 1940, and Ford Motor Company converted its assembly lines to produce military vehicles. The construction of the Watterson Expressway began in 1949, opening the door for travel and development throughout Jefferson County. General Electric broke ground on its Appliance Park in 1951, and Ford opened its Louisville Assembly Plant in 1955. Jefferson County's focus transitioned from agriculture to manufacturing.

Though once an agricultural community known for its ample water supply and fertile soil, Fern Creek experienced changes in the 1950s that altered the landscape, transformed the economy, and impacted rural lifestyles. As the population grew and the suburbs expanded with the outgrowth created by the Watterson Expressway, more businesses and institutions opened along major transportation routes like Bardstown Road. The number of churches in Fern Creek grew significantly during that time. Some of the earliest schools in the area began in Fern Creek, and the high school was the first four-year program to be recognized by the Jefferson County Public Schools. With the addition of the fire department and the community center, the residents of Fern Creek developed a strong sense of community pride that endures today.

The community now stretches from around the intersection of Watterson Trail and Bardstown Road as far south as the Bullitt County line and as far east as Broad Run Road. Today, Fern Creek is home to three golf courses. One is on a pre–Civil War farm where a judge magistrate lived. Another has a clubhouse that was converted from a Victorian mansion, which later burned.

For all the changes that have taken place, the road and the community pride remain. Once known as the Stage Road, Jackson Highway, or Highway 31 E, Bardstown Road still follows the path of the buffalo and connects Jefferson County to Bullitt County and on to Bardstown. Like the early settlers of Fern Creek, today's residents have all they need right here at home.

One

AGRICULTURE

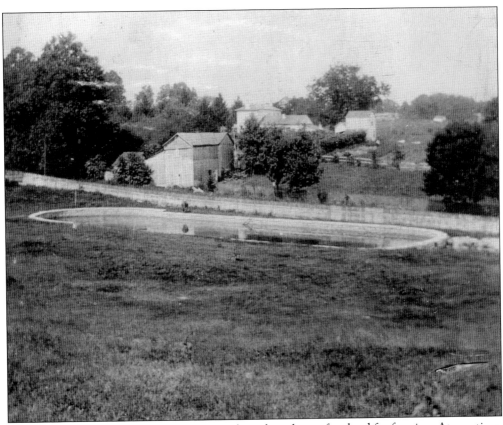

The abundant sources of water in Fern Creek made it the perfect land for farming. At one time, fruit orchards were plentiful in the area, and strawberries were the number-one crop. Farmers entered their crops in exhibitions at the Fern Creek Fair, held by the Farmers and Fruit Growers Association, which began in 1880. (Courtesy of Bonnie H. Fritschner.)

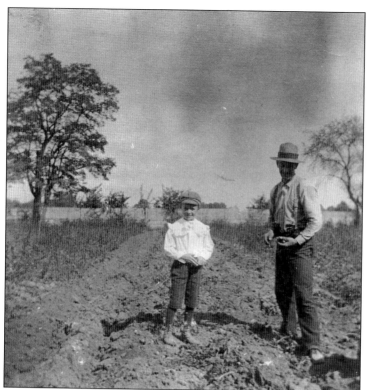

The Fern Creek Fair encouraged an interest in farming, and in 1900, the Jefferson County Fair Company was established on Fairgrounds Road. The large tracts of land granted in the 1700s were soon divided for farming and agricultural use. The fields were plowed and ready for planting with an eye toward the upcoming fair. (Courtesy of Bonnie H. Fritschner.)

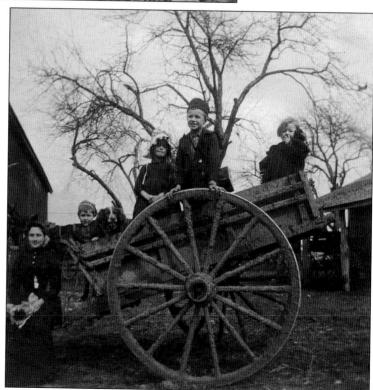

Children romp on an unhitched wagon near a barn in Fern Creek around 1900. The farm offered limitless opportunity for enjoyment and play. (Courtesy of Bonnie H. Fritschner.)

The many streams, springs, and creeks made the Fern Creek area favorable for livestock and agricultural production. (Courtesy of Bonnie H. Fritschner.)

Barn chores and taking care of the poultry and livestock often involved the whole family, as children were taught from an early age how to feed and tend the animals. (Courtesy of Bonnie H. Fritschner.)

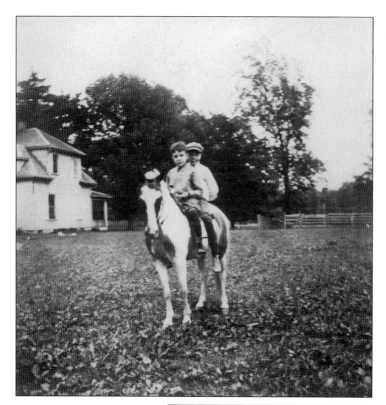

Jefferson County lagged behind other parts of the state in terms of horse and mule production, but the animals were used for enjoyment and out of necessity to run the farm. (Courtesy of Bonnie H. Fritschner.)

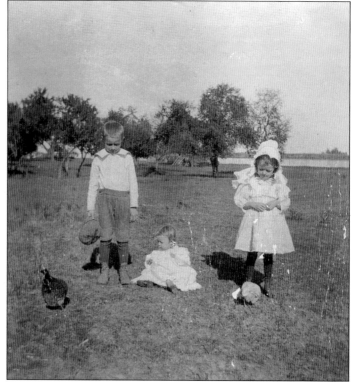

In addition to fruit and other field crops, farmers in Fern Creek expanded their agricultural practices into poultry and livestock. Many families had their own flocks, and a few opened hatcheries for larger poultry production. (Courtesy of Bonnie H. Fritschner.)

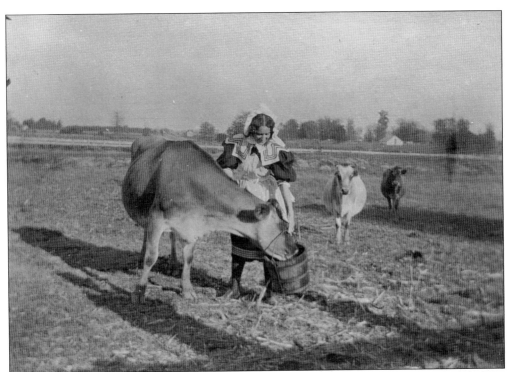

The main livestock in Jefferson County were hogs, sheep, and cattle. Cattle were raised both for dairy and for beef production. These cattle were hand-fed out of a bucket in a field in Fern Creek around 1900. (Courtesy of Bonnie H. Fritschner.)

Sheep were not listed as major livestock in Jefferson County, but some farmers kept them for their fleece and for dairy, as well as to use on the farm. Here, children enjoy playing with the animals and being led by rams on a wagon at Glenmary Farm around 1900. (Courtesy of Bonnie H. Fritschner.)

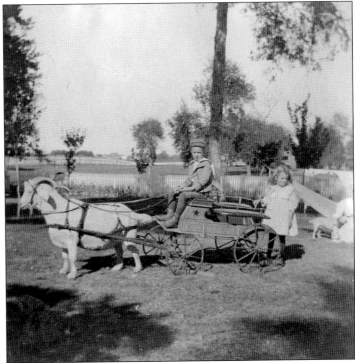

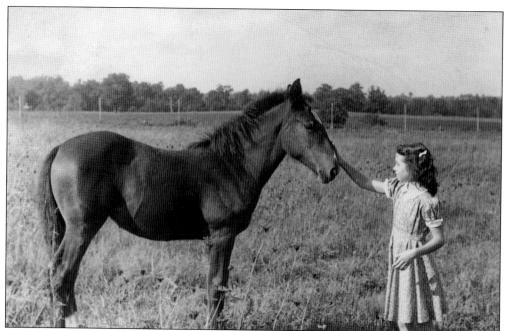

Bonnie Honaker, great-great granddaughter of Dennis Long (page 51), spent many summers at Glenmary Farm with her cousins. They slept together on the porch, swam in the spring-fed pool, and rode the family horses through the fields. The farm offered opportunities for all the children to become acquainted with a variety of animals. (Courtesy of Bonnie H. Fritschner.)

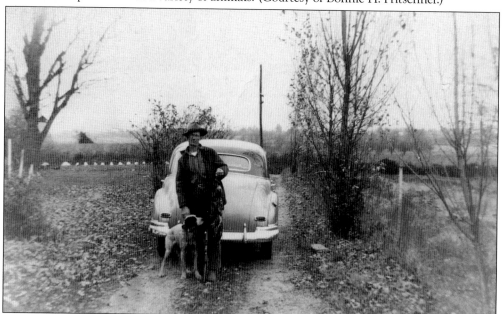

When W.H. Lusk moved to southeast Jefferson County in the 1940s, he chose the location for its higher elevation. The watermarks from the 1937 flood were still visible in parts of Valley Station and Pleasure Ridge Park, closer to the Ohio River. Much like the buffalo that carved out the early parts of the Wilderness Road, Lusk found an alternate route in case the water rose again. (Courtesy of Kathy Fraley.)

In the colder months, after crops were harvested, many farmers took advantage of the opportunity for time off from farm work to hunt birds and other wildlife in the barren, rural landscape. (Courtesy of Kathy Fraley.)

Like the early settlers of Fern Creek who divided their property amongst their offspring, W.H. Lusk gave his original 32 acres to his family. (Courtesy of Kathy Fraley.)

Two

Historic Homes and People

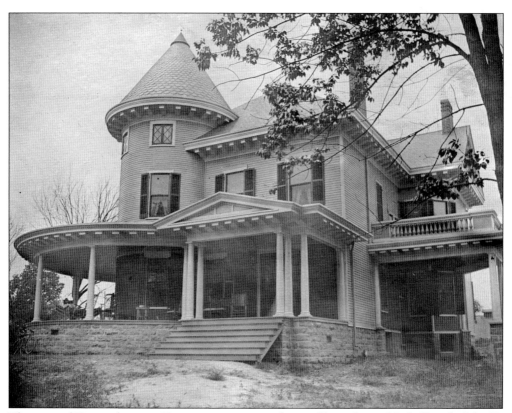

The original Taggart home, a 12-room mansion, was designed by architect J.J. Gaffney for John D. Taggart Jr. in 1899. The frame house, pictured here around 1900, boasted a slate roof, hardwood floors, an Italian marble bathroom, and a hot water heater. The Taggarts spent the rest of the year at their home in the Highlands with Florence Long Taggart's mother, Mary Geggus Long. (Courtesy of Bonnie H. Fritschner.)

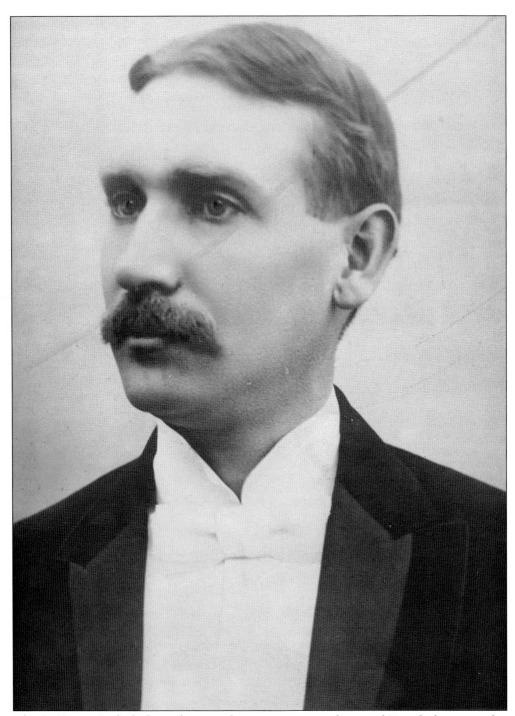

John D. Taggart Jr. died of complications from pneumonia at the age of 39, only five years after completing his dream home, known as Wildwood. His father, John D. Taggart Sr., founded Fidelity Trust and Safety Vault Company, which later became Citizens Fidelity Bank and Trust. Wildwood was a 175-acre farm upon which Florence Long and John D. Taggart Jr. built their summer home. (Courtesy of Bonnie H. Fritschner.)

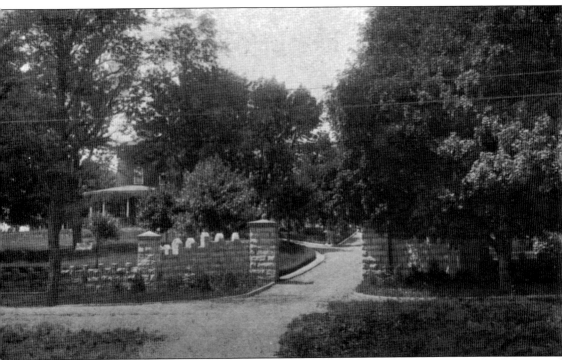

This 1907 view of the entrance to Wildwood from Bardstown Road shows the stone fence that surrounded the property. Lee Miles, who married widow Florence Taggart in 1907, lived at Wildwood in the summer. He later acquired Louisville Carriage and Taxicab Company. The company became Louisville Taxicab, Transfer Company, and later, Yellow Cab of Louisville. (Courtesy of Bonnie H. Fritschner.)

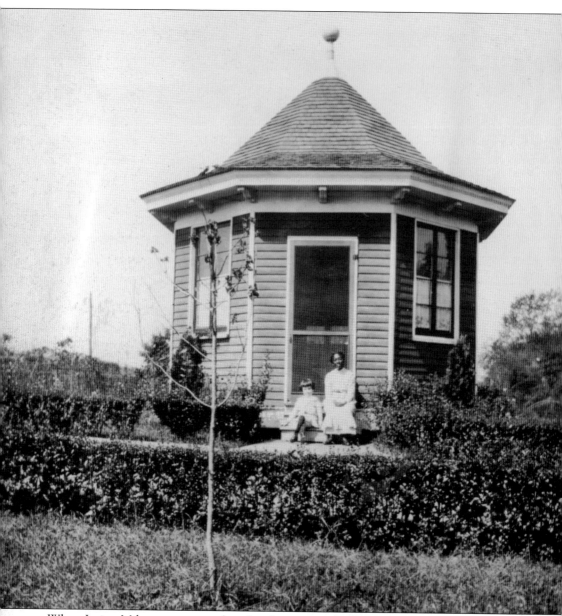

When Irving Miles was a young boy, his doctor specifically requested the services of Fannie Conway to help care for him because he was born with polio. The playhouse at Wildwood was built by Wildwood's original owner, John D. Taggart, for his daughter Mary Catherine. Irving later enjoyed playing there with his half-sister. (Courtesy of Bonnie H. Fritschner.)

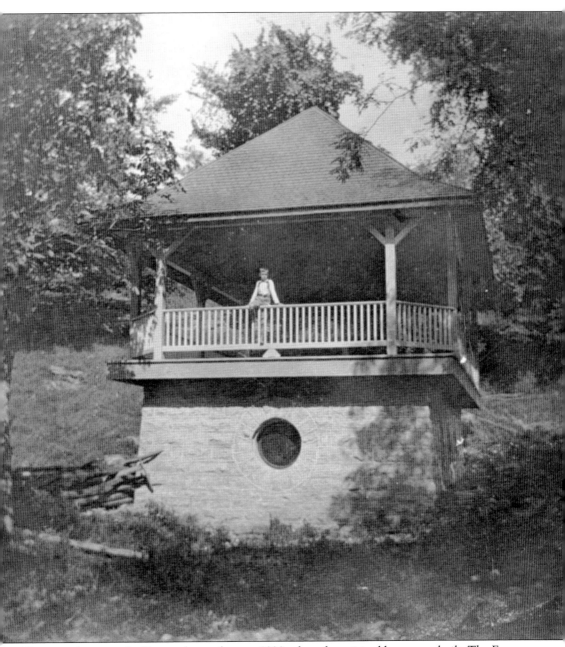

The springhouse at the Taggart home dates to 1899, when the original home was built. The Fern Creek community is named for the creek that runs through the property at 5000 Bardstown Road, now the home of Wildwood Country Club. (Courtesy of Bonnie H. Fritschner.)

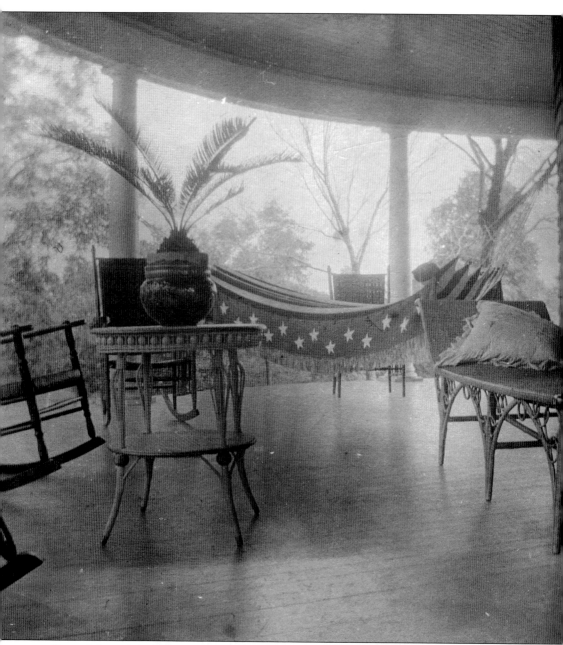

One of the original Taggart home's most distinguished features was the circular veranda, which wrapped from the front porch and extended down one side of the home. Marked by a signature round turret, the Taggart mansion was built in the Queen Anne style. (Courtesy of Bonnie H. Fritschner.)

The dining table of the Taggart home's original owners, John and Florence Long Taggart, extended to a banquet size using seven leafs and seated 18 people. (Courtesy of Bonnie H. Fritschner.)

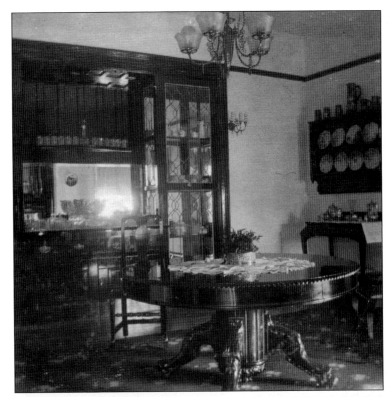

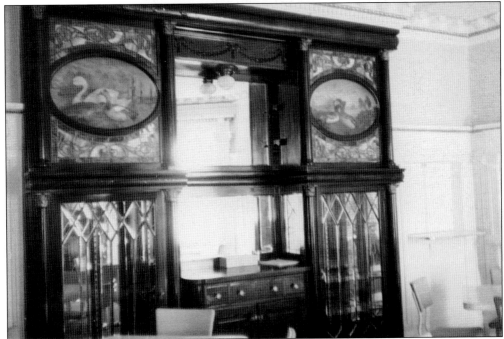

This china cabinet in the dining room at Wildwood Country Club belonged to Florence Long Taggart. Fire destroyed part of the clubhouse in 1987 and ruined the china cabinet. (Courtesy of Kentucky Heritage Council.)

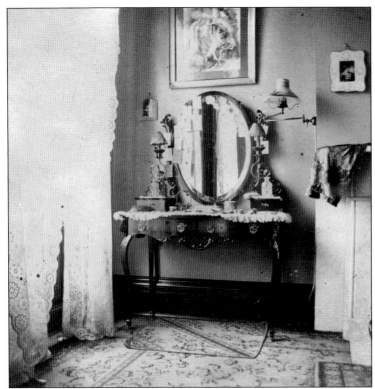

This vanity table inside the Taggart home is one of the fine furnishings that belonged to Florence Long Taggart. The home was featured in a January 28, 1900, article in the *Courier-Journal* along with others designed by architect J.J. Gaffney. (Courtesy of Bonnie H. Fritschner.)

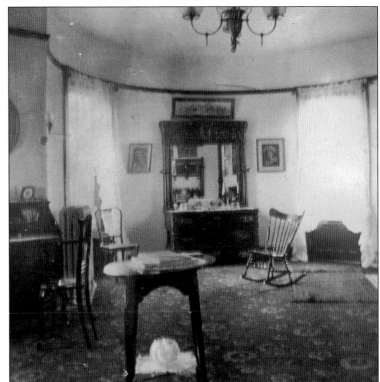

The round room inside the tower on the second floor of the Taggart home at Wildwood is pictured here around 1900. (Courtesy of Bonnie H. Fritschner.)

The living room of the Taggart house featured a kissing bench, a fireplace with wood-carved overmantel mirror, and vases. (Courtesy of Bonnie H. Fritschner.)

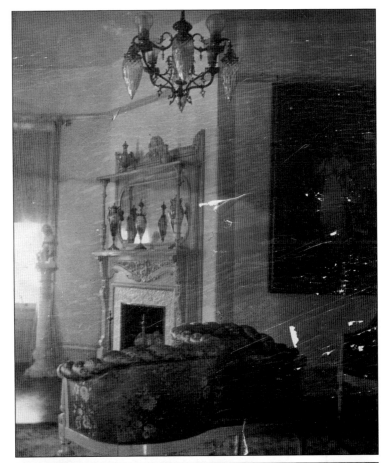

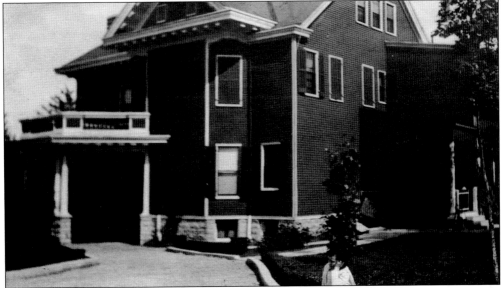

This c. 1910 view of the rear of the home at Wildwood from the driveway shows the home with a dark coat of paint on the exterior. (Courtesy of Bonnie H. Fritschner.)

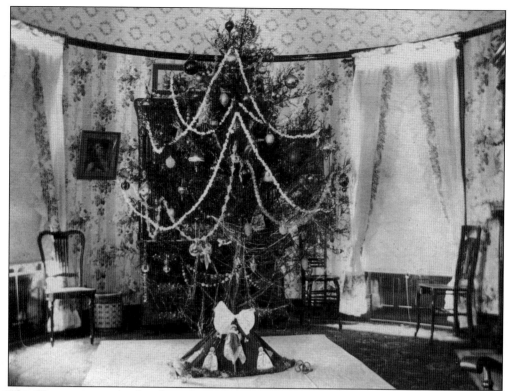

This Christmas tree stood in the Queen Anne room at Wildwood around 1900. The round room, popular in Victorian homes, was a feature of the home designed by J.J. Gaffney. The Queen Anne room featured intricate detailed woodwork and normally functioned as a parlor. (Courtesy of Bonnie H. Fritschner.)

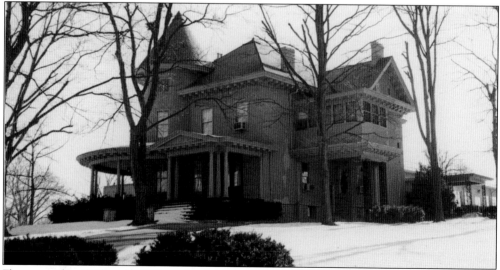

Florence and Lee Miles sold Wildwood in 1915. In 1952, Mr. and Mrs. Raymond Bischoff purchased the property for the purpose of organizing a golf and country club and successfully transformed the farm into Wildwood Country Club in 1953. A fire destroyed part of the clubhouse in 1987, and the house lost some of its original distinct design features. (Courtesy of Kentucky Heritage Council.)

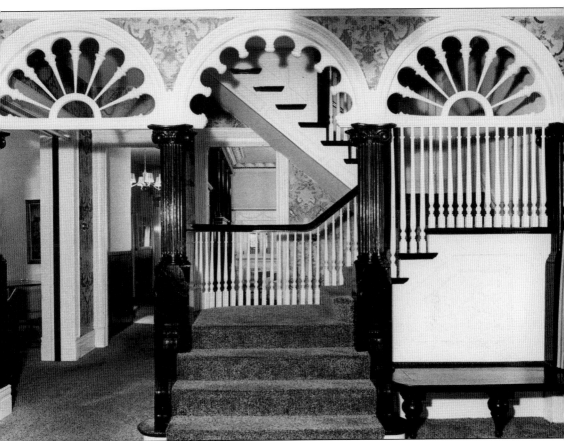

The elegant entryway to Wildwood highlights the intricate woodwork and stairway. The wood floors were covered with carpet when the former Taggart mansion was adapted for use as Wildwood Country Club. (Courtesy of Kentucky Heritage Council.)

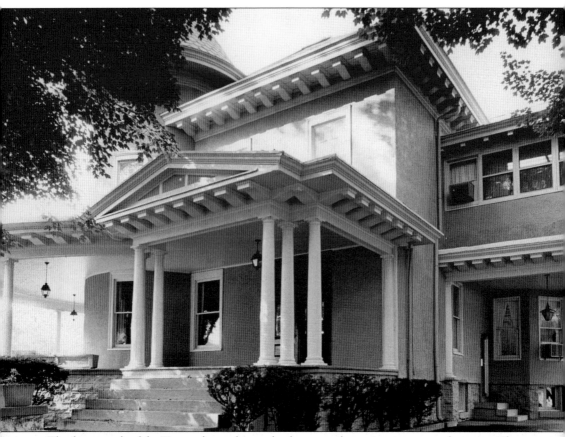

The front porch of the Taggart home featured columns at the main entrance and carport. Changes made to the property after it was sold by Florence and Lee Miles include a glass-enclosed porch above the carport. (Courtesy of Kentucky Heritage Council.)

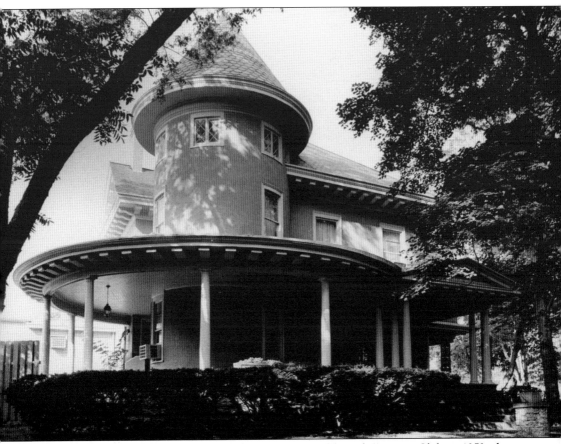

After the Taggart home was sold and reconstructed for Wildwood Country Club in 1953, the former frame exterior was replaced with stucco. The large wraparound veranda remained until the clubhouse burned in 1987. (Courtesy of Kentucky Heritage Council.)

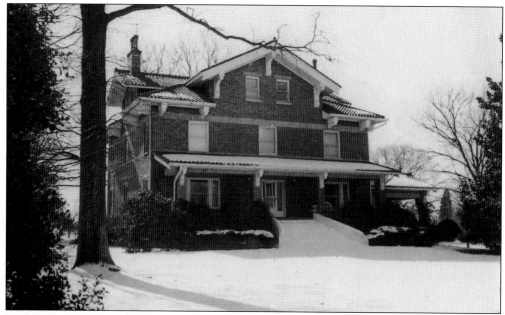

Patrick Bannon Sr.'s sons Martin and Patrick Jr. worked for their father's company, the P. Bannon Pipe Company, until it closed in the late 1920s. Patrick Sr. came from Ireland and began as a plasterer before manufacturing terra-cotta and vitrified sewer pipe. The two-and-a-half-story brick Patrick Bannon House was constructed around 1910 at 4518 Bardstown Road. (Courtesy of Kentucky Heritage Council.)

The Martin F. Bannon House at 5112 Bannon Crossings Drive is of similar design to the Patrick Bannon House, and both are thought to have been designed by the same architect, although no record exists confirming this. The P. Bannon Pipe Company later contributed terra-cotta work for the Louisville waterworks. (Courtesy of Kentucky Heritage Council.)

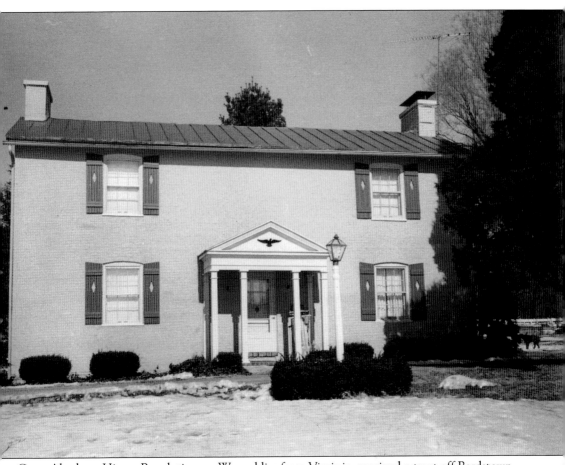

Capt. Abraham Hite, a Revolutionary War soldier from Virginia, received a tract off Bardstown Road at 4125 Starlite Lane and built this two-story brick home with stone foundation around 1790. Hite was subsequently designated by the state of Virginia as one of five commissioners of the Town of Louisville, with the power to sell lots and levy taxes. He became a county court judge and later served in the senate. (Courtesy of Kentucky Heritage Council.)

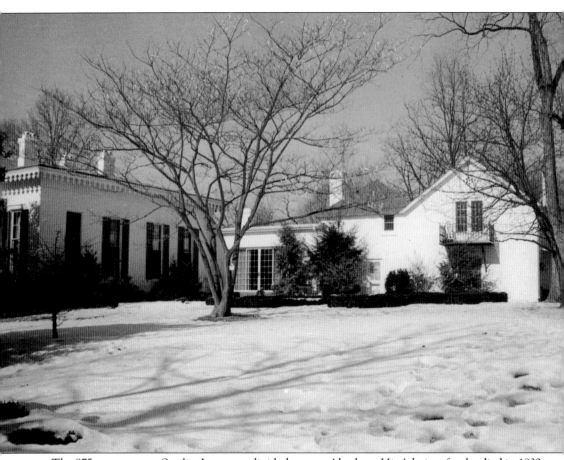

The 975-acre tract on Starlite Lane was divided among Abraham Hite's heirs after he died in 1832, with his son Isaac inheriting the parcel with the house. Isaac died in 1849. The property was sold to Stephen Chenoweth, who is thought to have built this house, known as the Hite-Chenoweth House, at 4219 Starlite Lane, around 1850. (Courtesy of Kentucky Heritage Council.)

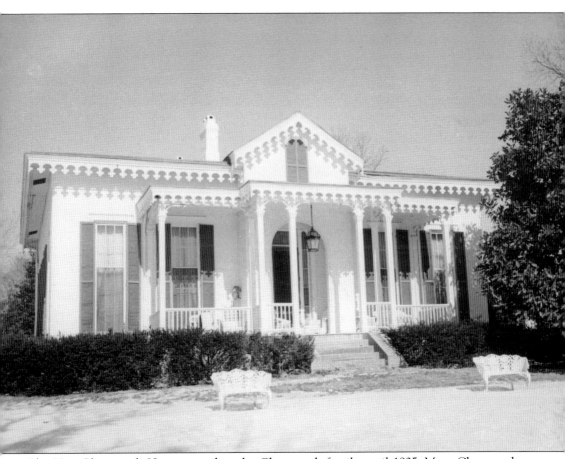

The Hite-Chenoweth House stayed in the Chenoweth family until 1935. Mary Chenoweth, daughter of Stephen, married Franklin Gaar, a neighbor. Their son Charles inherited the house. The one-story brick house with a raised basement was listed in the National Register of Historic Places in 1980. (Courtesy of Kentucky Heritage Council.)

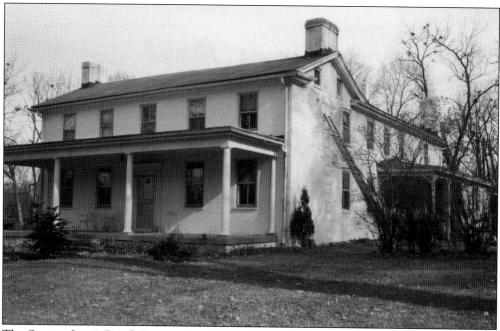

The Simeon Lewis Rural Historic District, at 5215 Bardstown Road, is listed in the National Register of Historic Places. The historic district includes the main house, which also served as an inn and tavern also known as Kellar Tavern, Fern Cliff, Nine Mile Tavern, and Peacock Inn. (Courtesy of Kentucky Heritage Council.)

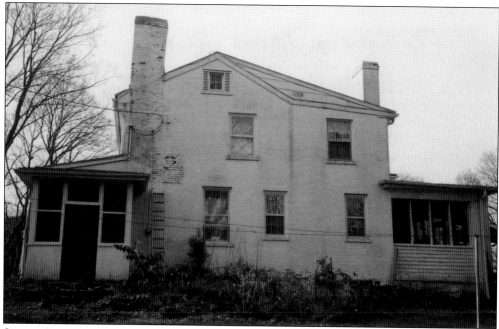

Simeon Lewis was a prosperous farmer who also operated a stagecoach service. Many homeowners in the Fern Creek area operated inns and restaurants or taverns for travelers needing a place to stop for the night as they made their way between Louisville and Bardstown. (Courtesy of Kentucky Heritage Council.)

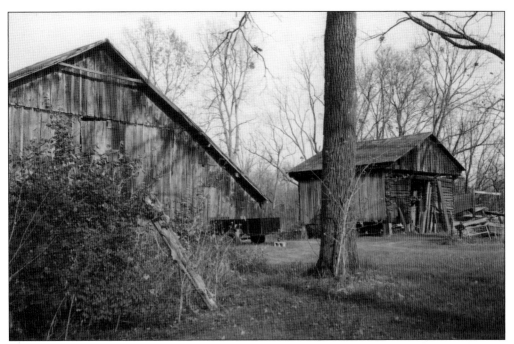

The barn and corn crib of the Simeon Lewis Rural Historic District were constructed around 1851. The corn crib originally stored grains to feed animals. The bank barn featured multiple levels for hay and feed storage as well as other uses. (Courtesy of Kentucky Heritage Council.)

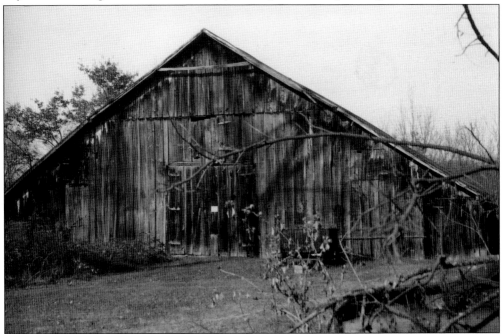

Bank barns were typically built into the side of a hill so it was easier to access the multiple levels. At one time in the late 1800s, the barn of the Simeon Lewis Rural Historic District housed 35 horses and may have been used to store stagecoaches for travelers who stopped for the night as they made their way between Louisville and Bardstown. (Courtesy of Kentucky Heritage Council.)

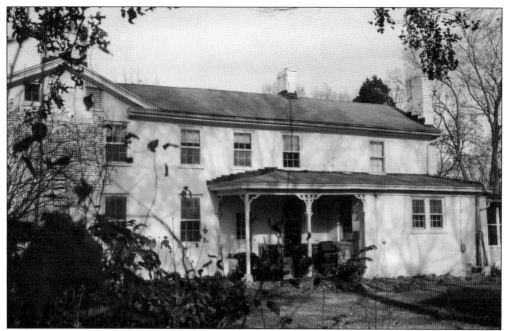

The main house of the Simeon Lewis Rural Historic District is a two-story Greek Revival–style design and was built around 1830, with additions in 1855. The house features a stone foundation and brick exterior painted white. The wood-shingled roof was replaced with asphalt tiles in the 1950s. (Courtesy of Kentucky Heritage Council.)

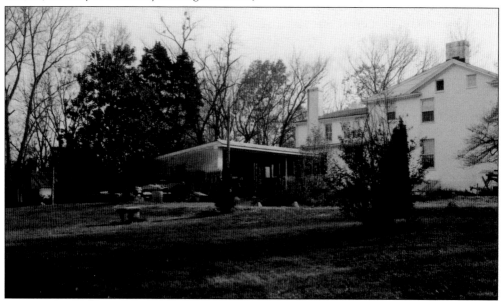

The one-story kitchen was originally detached from the home of the Simeon Lewis Rural Historic District but later connected by an addition. Simeon Lewis declared bankruptcy in 1874. The farm was auctioned and the land was subdivided, while the tract with the house and outbuildings went to J.P. Lithicum, whose widow later sold the property to Bryan and John Williams. Bryan Williams later cofounded the Fern Creek Fruit Fair and organized the Jefferson County Fair Company, of which he was president. (Courtesy of Kentucky Heritage Council.)

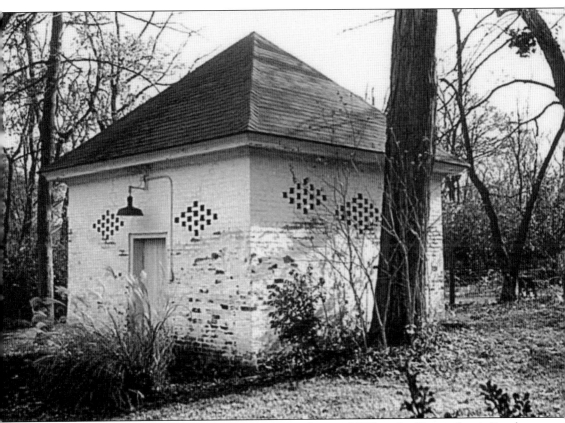

Farm outbuildings, such as this smokehouse constructed around 1851 in the Simeon Lewis Rural Historic District, were typically placed in close proximity to the main residence for ease of use. Farm complexes included multiple buildings, each designed for specific farming activities. (Courtesy of Kentucky Heritage Council.)

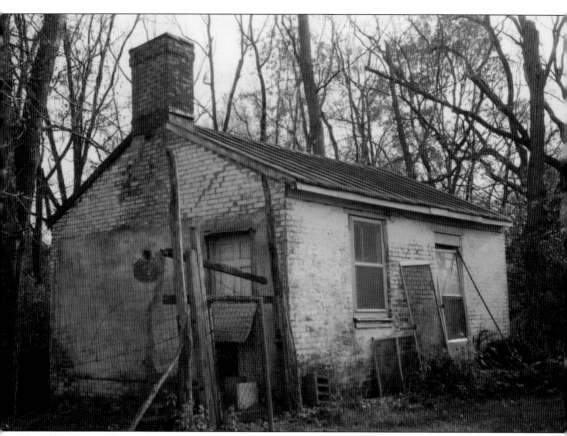

The Simeon Lewis Rural Historic District, a pre–Civil War farm, included an enslaved African American residence/tenant house. Farmers who employed slave labor typically built residences for the slaves on the farm. The number of residences erected depended on the number of slaves employed. Unlike other servant quarters, which are typically of log or frame construction, this one was made of brick. (Courtesy of Kentucky Heritage Council.)

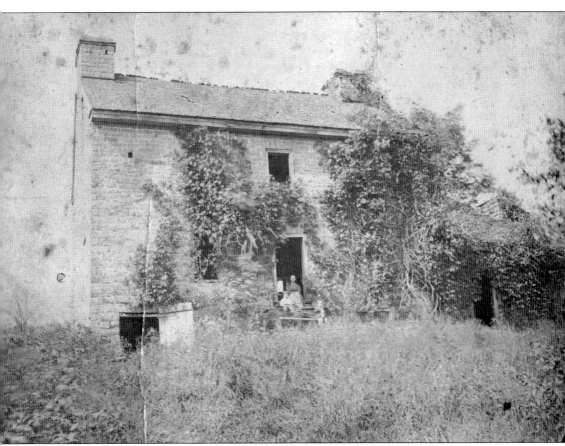

The Guthrie Homestead was home to James Guthrie, a Revolutionary War veteran from Delaware, who was granted 1,199 acres in Fern Creek. Guthrie built the home from stone quarried from nearby Cedar Creek. The home was a regular stopping place for travelers to Bardstown from downtown Louisville and the Falls of the Ohio. (Courtesy of Beulah Presbyterian Church.)

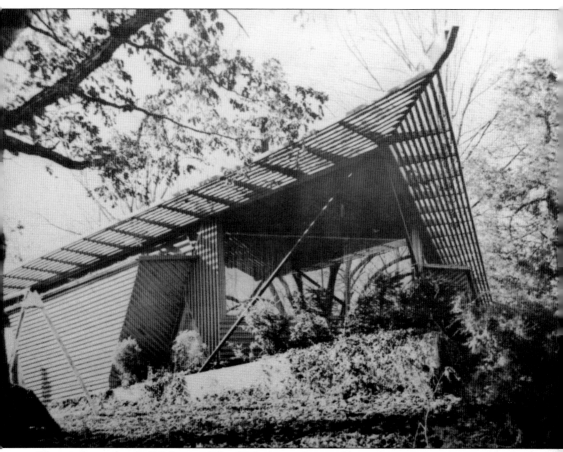

Triaero, located at 8310 Johnson School Road, was designed by architect Bruce Goff and built in 1942. Goff designed the home for Irma Bartman, whose son, Kenneth, studied under Goff at the Chicago Academy of Fine Arts. Goff studied under Frank Lloyd Wright. The triangular home is supported by a steel frame of three columns. (Courtesy of Kentucky Heritage Council.)

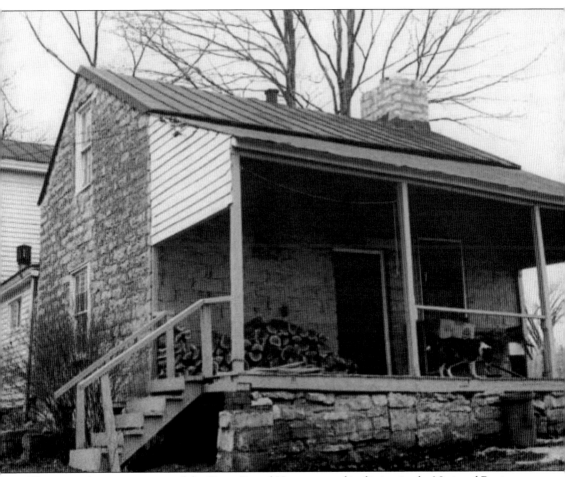

The original stone structure of the Omer-Pound House earned its listing in the National Register of Historic Places due to the 15-inch-thick stone walls made of Kentucky limestone. The house was built in the late 1700s by Daniel Omer. Dr. Thomas Pope Dudley Pound, a Seatonville physician, bought the property in 1906 and it remained in the Pound family until 1979. (Courtesy of Kentucky Heritage Council.)

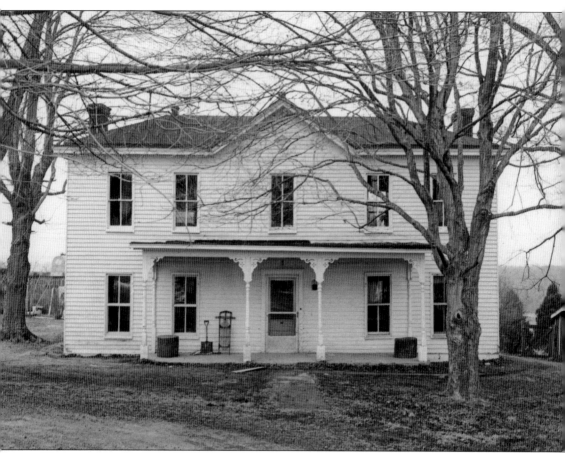

The two-story frame farmhouse was added to the Omer-Pound House around 1870. Daniel Omer sold part of the land to Peter Omer, who is thought to have been his son, in 1830. The Omers owned the property until it was sold to Edward Yeager in 1876. (Courtesy of Kentucky Heritage Council.)

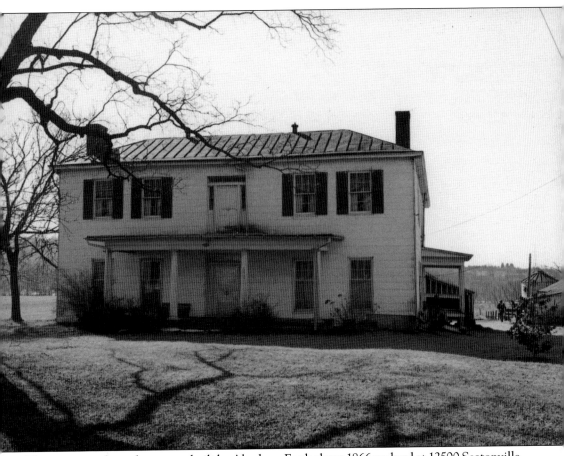

This two-story frame house was built by Abraham Funk about 1866 on land at 12500 Seatonville Road deeded to him by his father, Peter Funk of German descent, who settled in Jefferson County in the late 1700s. Funk's Mill, first built by John Mundell and later purchased by the Funks, sat behind the house on Floyd's Fork and operated until 1876. (Courtesy of Kentucky Heritage Council.)

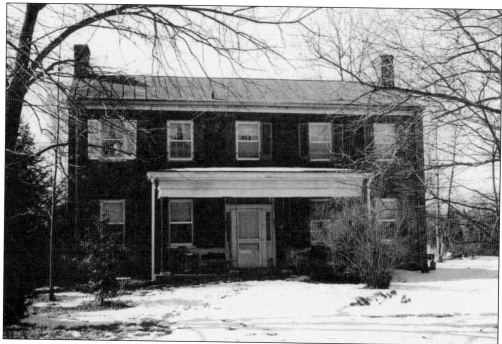

James Guthrie was the original owner of the property known as the Levin Bates House. Guthrie was a Revolutionary War hero who was given a sizeable land grant in Fern Creek that was divided amongst his heirs upon his death. (Courtesy of Kentucky Heritage Council.)

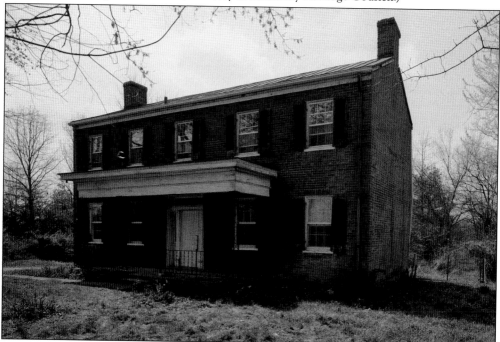

James Guthrie's daughter Sarah was married to Jacob Johnson, and they received 122.5 acres. When Jacob died, the deed was transferred to his youngest daughter, also named Sarah, and her husband, Levin Bates. (Courtesy of Kentucky Heritage Council.)

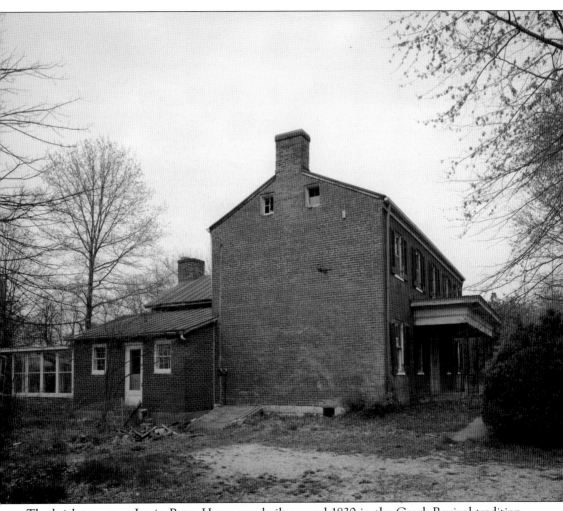

The brick two-story Levin Bates House was built around 1830 in the Greek Revival tradition with a one-story addition in the rear. The house was listed in the National Register of Historic Places in 1980. (Courtesy of Kentucky Heritage Council.)

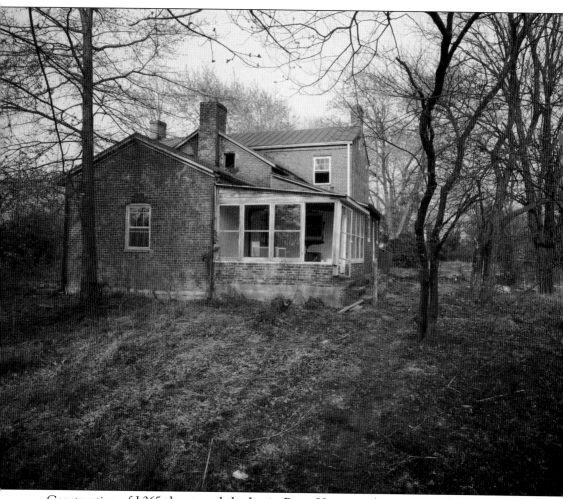

Construction of I-265 threatened the Levin Bates House, and it was moved from its historic location at 7300 Bardstown Road to Wingfield Lane for preservation purposes. The property sat vacant for two years after the state purchased it before its relocation. At one time, a log cabin, a log barn, a frame barn, a chicken coop, a hog pen, and a smokehouse existed on the property. (Courtesy of Kentucky Heritage Council.)

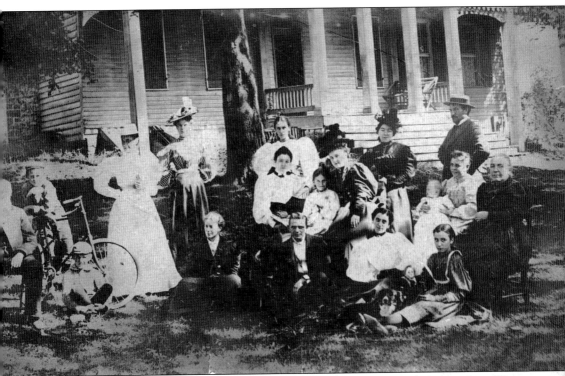

The McKenna home was originally owned by Col. George Hancock. It was later known as Glen Cony. The McKennas purchased the property and ran a summer hotel there for a number of years. The McKenna Farm adjoined Glenmary Farm. Later, Dennis Long's grandson George married Corrinne McKenna. Over time, the Longs purchased parcels from the McKennas, eventually absorbing the entire McKenna property. (Courtesy of William Nold.)

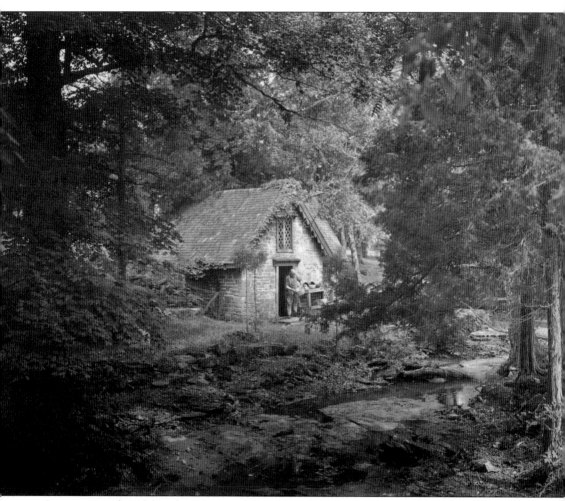

Springs were plentiful in the Fairmount district, and many people had springhouses like this one belonging to the McKennas. (Courtesy of Corrinne Nold and Pamela Gregory.)

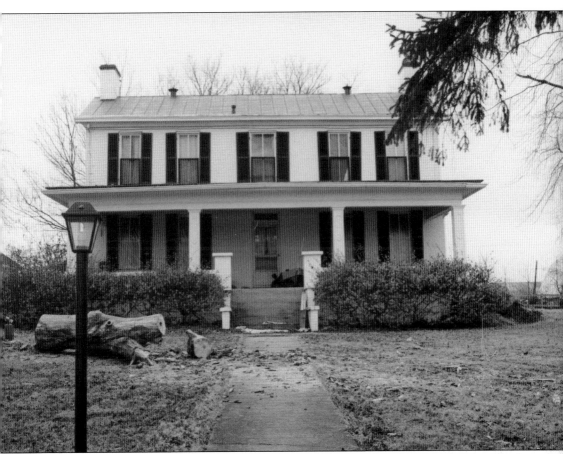

The two-story brick Snapp House at 8300 Bardstown Road is listed in the National Register of Historic Places. The Federal-style house was built around 1800 on land once owned by James Guthrie. Lewis Snapp purchased the land in 1845. After his death, Snapp's heirs sold the house in 1876. (Courtesy of Kentucky Heritage Council.)

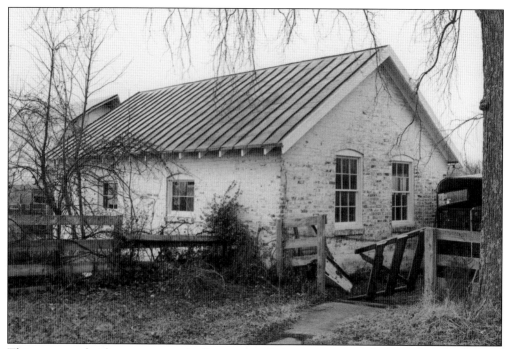

This one-story brick structure on the Snapp property is consistent with the style typically built for enslaved African American residences/tenant houses, although there is no historical record confirming this. (Courtesy of Kentucky Heritage Council.)

This small frame building on the Snapp property served as Dr. William Farmer's office. The building features a gabled entrance and fleur-de-lis bargeboard trim. Dr. Farmer owned the property from 1899 until 1913. His heirs sold the property to the McCullough family in 1938. (Courtesy of Kentucky Heritage Council.)

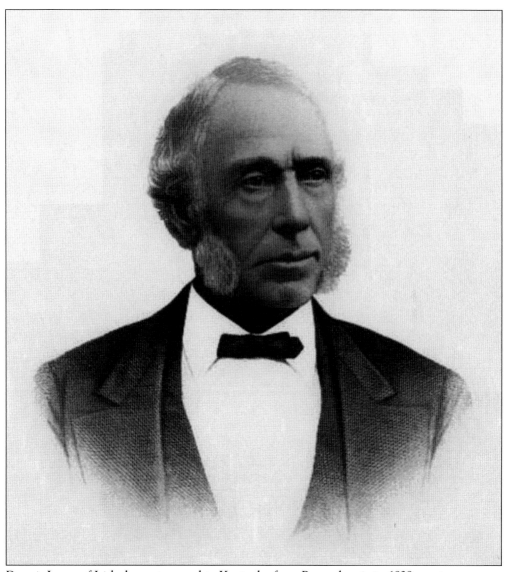

Dennis Long, of Irish descent, moved to Kentucky from Pennsylvania in 1838 as a journeyman molder, making castings for steamboats. Eventually, he started his own cast-iron foundry and machine shop making gas and water pipes for other cities before making the Cornish pumping engines for the Louisville waterworks. He invested in Southern Railroad and the Big Four Bridge, but did not live to see the bridge's completion. (Courtesy of Bonnie H. Fritschner.)

The original entrance to Glenmary Farm was on the Old Bardstown Pike around 1900. Dennis Long purchased the property from Charles Hall in the 1860s. Dennis liked to drive to Glenmary Farm on Sundays with his wife, Catherine Young Long, and their children. The fence bordering the property was torn down and moved when the property was later sold. (Courtesy of Bonnie H. Fritschner.)

The front of the main house at Glenmary Farm is pictured here. Three homes existed on the property that once belonged to Col. George Hancock: Glen Mary, Glen Cony, and Glen Hope. When Dennis Long purchased the property, he turned the main house, known as Glenmary, and reoriented the facade. (Courtesy of Hon. George Long.)

When visitors came to Glenmary via horse-drawn wagon or on horseback, they hooked their reins to this hitching post in front of the house. (Courtesy of William Nold.)

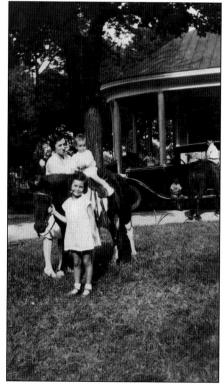

In the 1800s, Dennis Long raised Shetland ponies on Glenmary Farm. His grandson George purchased the property in 1900 and continued the tradition Dennis started. Dennis's great-granddaughter Mary Catherine Taggart Honaker brought her children Bonnie Honaker and Kitty Lee Honaker to ride the ponies around 1930. (Courtesy of Bonnie H. Fritschner.)

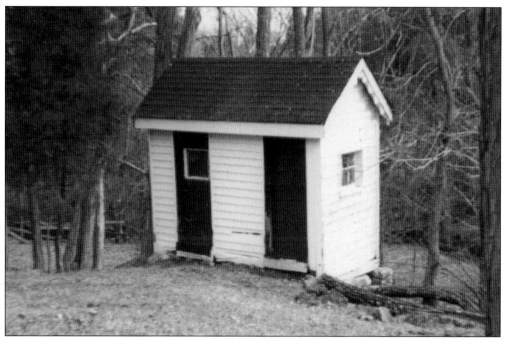

The outhouse at Glenmary Farm offered his and hers rooms, as there was no indoor plumbing in the original buildings. (Courtesy of William Nold.)

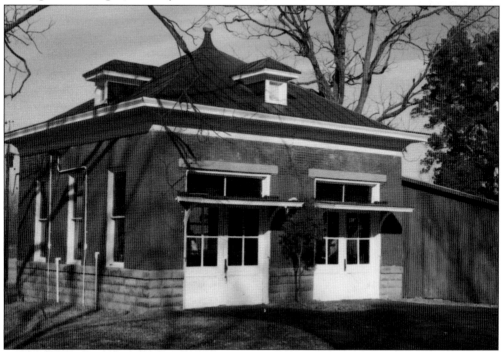

With no fire department in the 1800s in rural areas, farmers typically had to draw from wells or ponds in case of a fire. Dennis Long purchased a fire pumper truck and stored it in a garage on the property. Water from the pool was used to fill the hoses of the fire pumper truck in case of fire. (Courtesy of William Nold.)

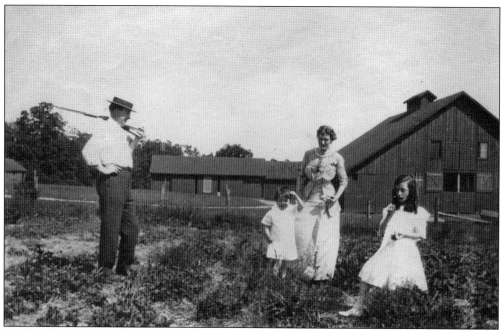

Lee Miles, an avid pheasant hunter, took advantage of the hunting opportunities at Glenmary Farm with his wife, Florence Long Miles; his son Irving; and his stepdaughter Mary Catherine Taggart. Florence's grandfather Dennis Long installed an exercise ring for the Shetland ponies. (Courtesy of Bonnie H. Fritschner.)

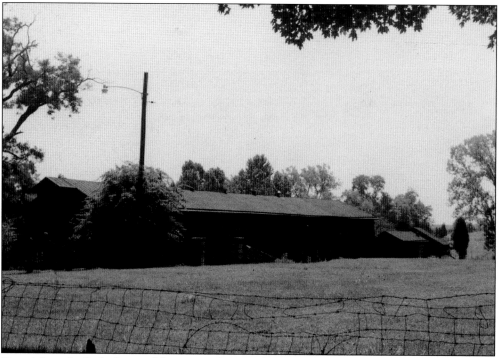

Dennis Long built the livestock barn extra long in the 1860s to house the Shetland ponies, sheep, and cattle the family raised on Glenmary Farm. (Courtesy of William Nold.)

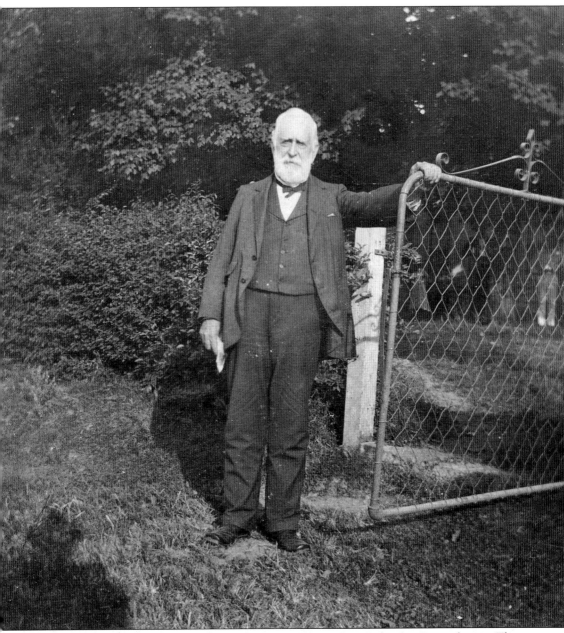

John Long moved with his brother Dennis and their parents from Ireland to Pennsylvania. The brothers later moved to Kentucky, where Dennis founded Dennis Long and Company, manufacturers of cast-iron pipe. John Long lived at Glenmary Farm year-round, while Dennis resided downtown near his company. (Courtesy of Bonnie H. Fritschner.)

Cows and sheep roamed freely over the 432-acre Glenmary Farm in Fern Creek. Dennis Long and his brother John (and later, his son George and grandson George) raised Shetland ponies, sheep, and cattle on the family property. (Courtesy of Bonnie H. Fritschner.)

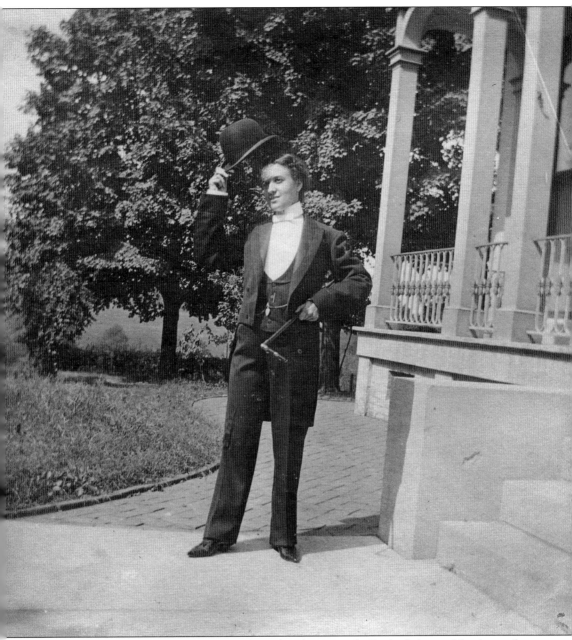

George Long, grandson of Dennis Long, is dressed in the Kentucky Derby fashion of the day, with hat, waistcoat with tails, and a cane around 1900. George, whose father was Dennis M. Long, purchased Glenmary Farm in 1900 and was the first generation to make Glenmary his home year-round. (Courtesy of Bonnie H. Fritschner.)

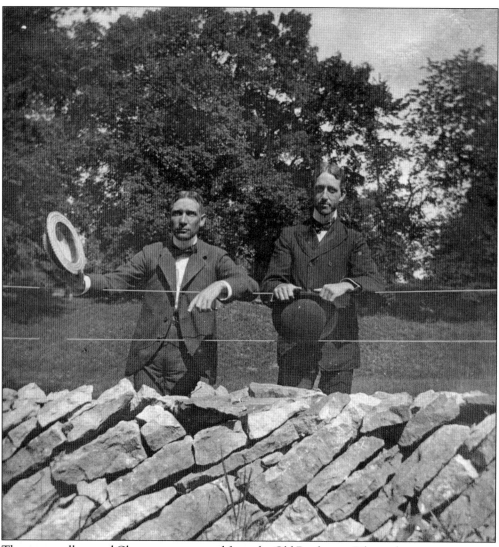

The stone wall around Glenmary was moved from the Old Bardstown Pike to the present entrance on Bardstown Road. During the Great Depression, with many men in the area unable to find work, George Long hired some to build a stone wall the length of his property. In exchange for their work, the men received $1 a day and a hot meal. (Courtesy of Hon. George Long.)

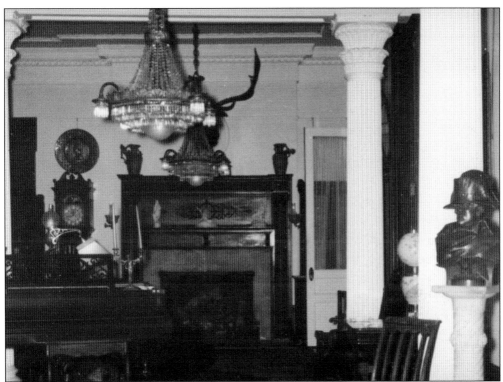

The front hall of Glenmary housed a bronze bust of Napoleon Bonaparte. Dennis Long admired Napoleon and was an avid collector of Napoleon memorabilia. He purchased the piano because he was told it had been played by some of Napoleon's children. On top of the piano was a cloth once worn by Napoleon. (Courtesy of Glenmary Golf Club.)

The formal dining room at Glenmary was a place for family gatherings. The original dining room and kitchen were left intact when the house was purchased by George Long in 1900, and new ones were later added. (Courtesy of Glenmary Golf Club.)

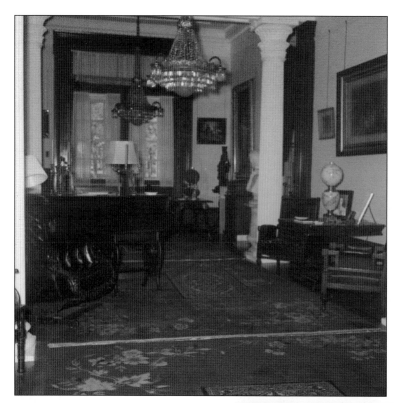

The house at Glenmary had 10-foot ceilings in all the rooms, windows from floor to ceiling, and all original hardwood flooring covered in rugs. Each room had its own fireplace with a bronze clock on the mantle. (Courtesy of Hon. George Long.)

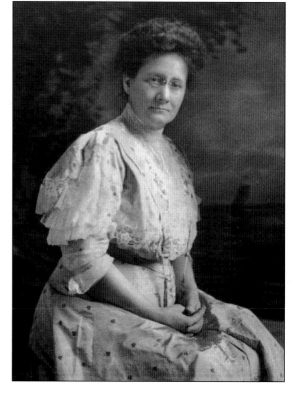

Mary Geggus Long was the widow of Dennis M. Long, who died an early death at the age of 46. At the time of his death, Dennis was superintendent of his father's company, Dennis Long and Company, a pipe foundry known for manufacturing cast-iron gas and water pipe. He and Mary had three children: Katie, Florence, and George. (Courtesy of Bonnie H. Fritschner.)

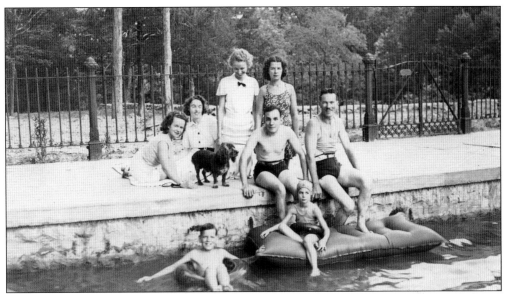

Irving Miles, his niece Bonnie Honaker, and other Long family children and their friends and pets enjoy a summer day at the pool at Glenmary, the family summer home, around 1938. Turtles and frogs swam alongside the children in the pool. (Courtesy of Bonnie H. Fritschner.)

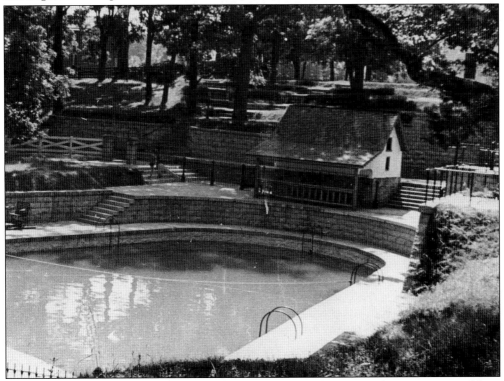

Water flowed in one end and out the other of the spring-fed pool at Glenmary, pictured here around 1938. The unique pool had stone sides and was nine feet deep with a dirt bottom. The water was also used to fill the hoses of the family's onsite fire pumper truck. (Courtesy of Bonnie H. Fritschner.)

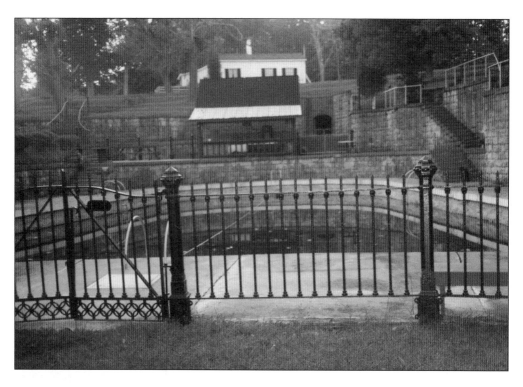

The pool Dennis Long built was large enough to store water for use on the farm and at the main house, in addition to swimming. (Both, courtesy of Hon. George Long.)

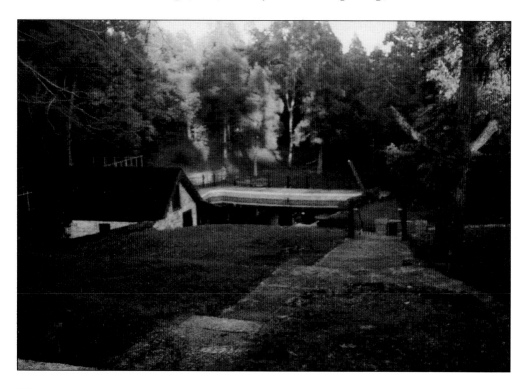

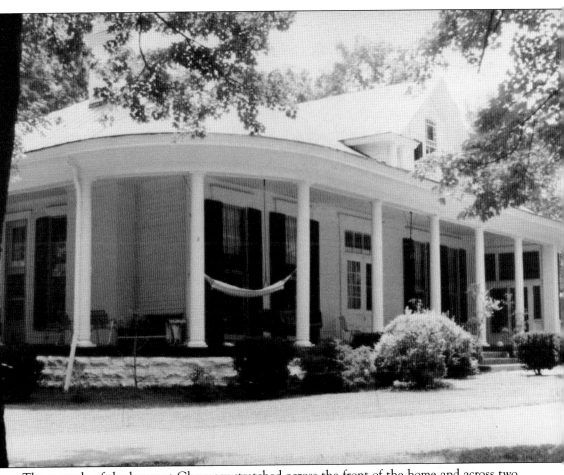

The veranda of the house at Glenmary stretched across the front of the home and across two sides. When visiting family members came to stay during the summer, cousins often slept together on the open porch. The right side of the porch was enclosed for use as the pro shop of Glenmary Golf Club. (Courtesy of Glenmary Golf Club).

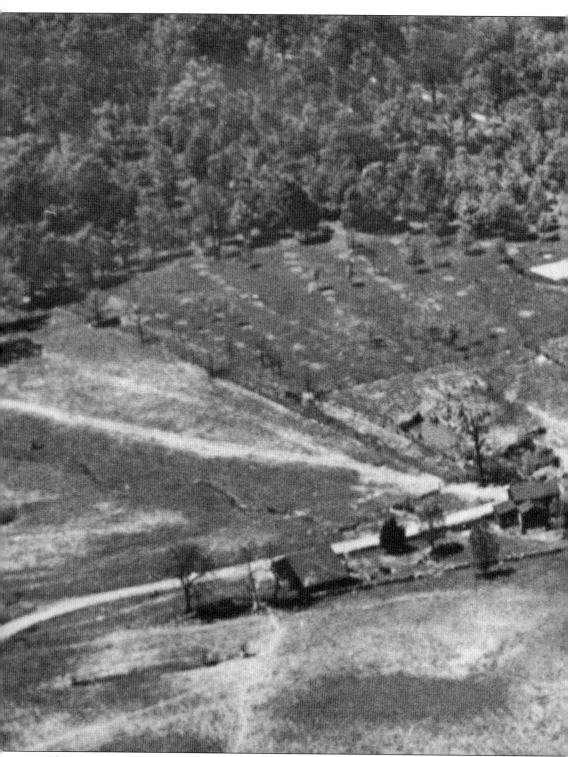

This aerial photograph of the 432-acre Glenmary Farm taken prior to 1970 shows the old Bardstown Road. Also pictured to the right is a road, no longer in existence, that once led to

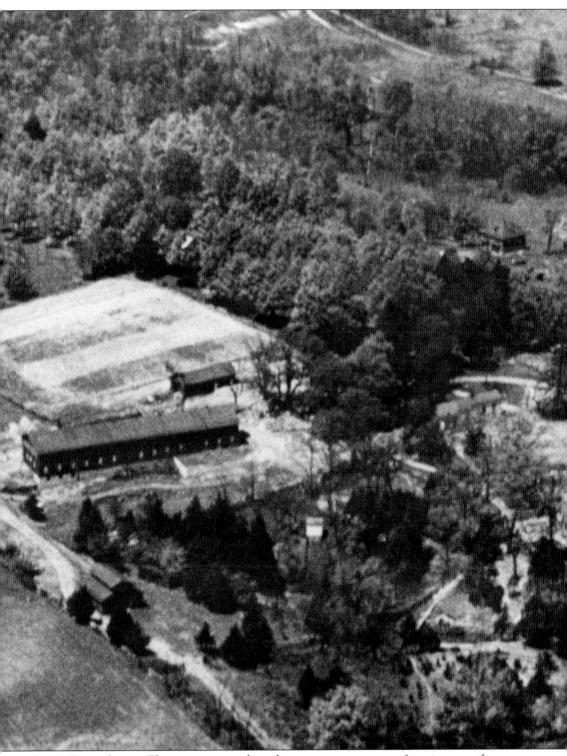

the McKenna house. The trees surrounding the property were one of its signature features. (Courtesy of William Nold.)

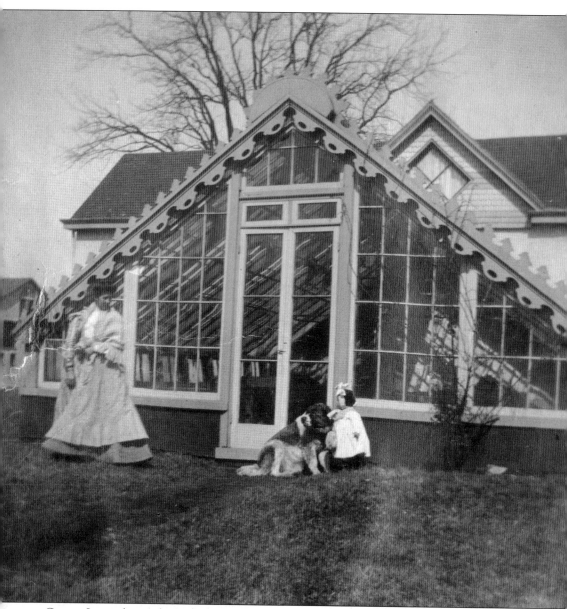

George Long obtained a special permit to raise raccoons and built a house for them to live in next to one of the small cottages where he lived. The raccoon house was made of glass, with structures for the raccoons to climb and play on, and also had a six-by-nine-foot pool that was one foot deep. (Courtesy of Bonnie H. Fritschner.)

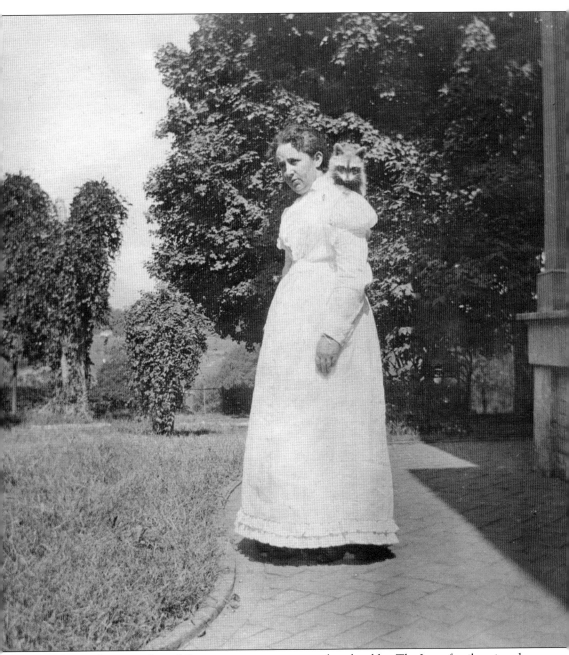

Mary Geggus Long, mother of George, sports a raccoon on her shoulder. The Long family enjoyed playing with the raccoons at Glenmary Farm. Grandchildren told tales of entering the raccoon house to feed and play with them as they would with the other animals on the farm. (Courtesy of Bonnie H. Fritschner.)

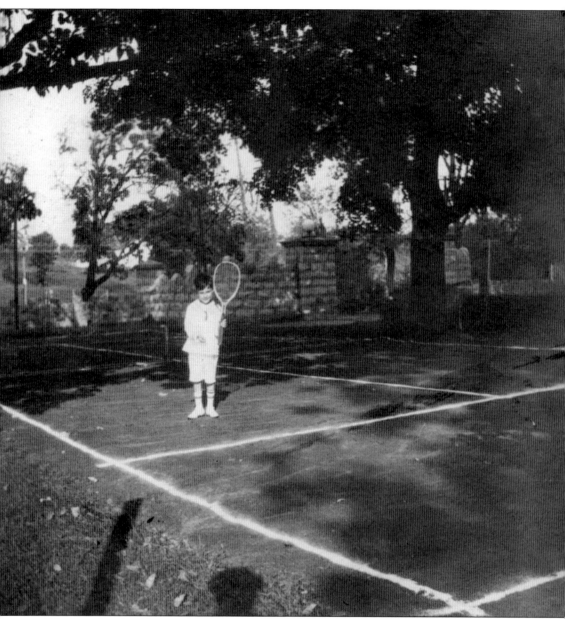

The Long family added a tennis court at Glenmary in the early 1900s when Evelyn Long, daughter of George, contracted tuberculosis. The doctor recommended exercise as a course of treatment. Many generations thereafter enjoyed the court, and it is still in use today by the residents of Glenmary subdivision. (Courtesy of Bonnie H. Fritschner.)

One of two guest cottages on Glenmary Farm housed famous zoologist Dian Fossey while she served as director of occupational therapy at Kosair Children's Hospital in 1955. She went to Africa in 1963 and later embarked on a study of endangered primates of Rwanda. Her book about the study, *Gorillas in the Mist*, was later adapted for film. Fern Creek's famous boxer, Marvin Hart, is rumored to have trained on Glenmary Farm. (Courtesy of William Nold.)

During the Civil War, Southern forces hid their horses under the Long Falls at Glenmary Farm. The falls were an outlet for the water that flowed through the farm and was usually contained in underground springs such as the one that fed the pool. After the Yankees had passed, the soldiers brought their horses out of hiding. (Courtesy of William Nold.)

Three

CHURCHES

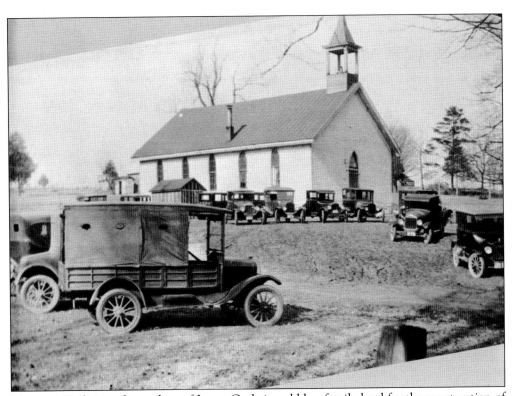

Margaret Guthrie, a descendant of James Guthrie, sold her family land for the construction of Beulah Presbyterian Church, whose original congregants were members of Pennsylvania Run Presbyterian. The Old Stone House, as the Guthrie homestead was called, served as the original meetinghouse until the church was built in 1870. The one-room frame building featured Gothic windows and a steeple holding the church bell. (Courtesy of Beulah Presbyterian Church.)

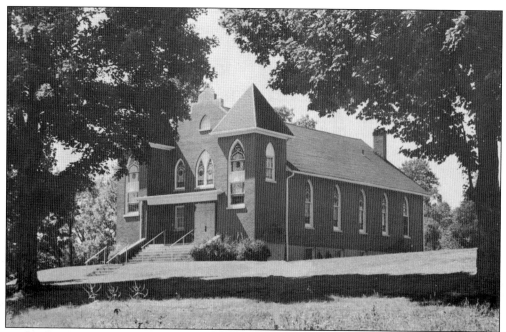

In 1927, Beulah Presbyterian Church was reconstructed. The walls were covered in brick, and a basement was added to give space for classrooms, a fellowship hall, and dining facilities. Stained-glass windows were installed in the Gothic frames from the original building. (Courtesy of Beulah Presbyterian Church.)

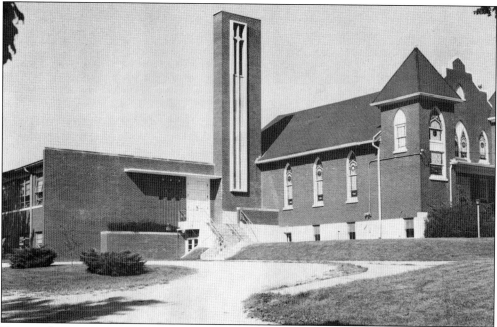

To meet the growing needs of its congregation, several improvements have been made to Beulah Presbyterian Church through the years. An education building was added in 1955, and later, a new sanctuary was constructed in 1967. Administrative offices and a library were added in the former sanctuary. (Courtesy of Beulah Presbyterian Church.)

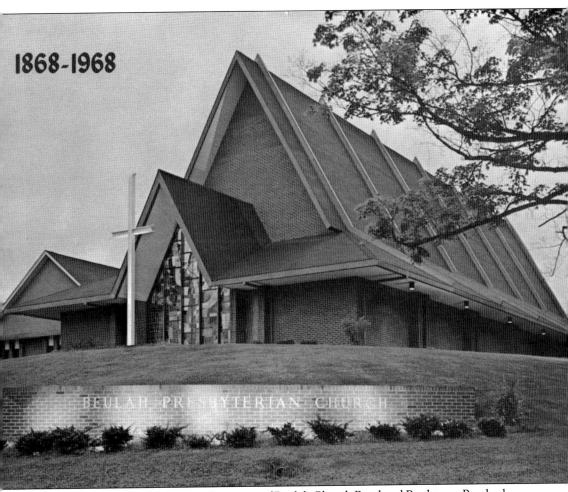

1868-1968

Beulah Presbyterian Church sits at the corner of Beulah Church Road and Bardstown Road, where it has occupied historic property for more than 145 years. James A. McCullough served as the first minister from 1878 to 1893; other ministers serving the church included E.W. Elliott (1904), William A. Ramsey (1912–1920 and 1926–1941), R.J. Hunter (1920–1925), Dr. W.A. Benfield (1941–1944), Richard Burn (1944–1948), John DeKruyter (1950–1951), and Dr. H.G. Goodykoontz (1952 and 1960–1961). (Courtesy of Beulah Presbyterian Church.)

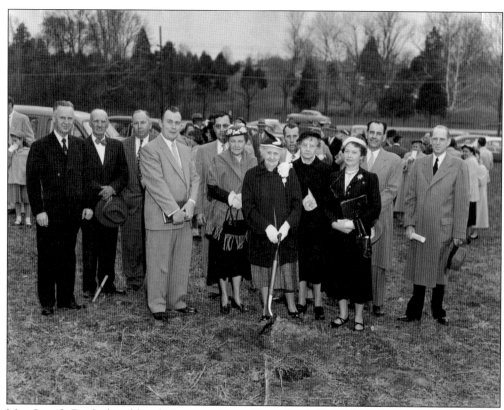

Mrs. Joseph Reid, the oldest living member of Fern Creek United Methodist Church, turned the first shovel of dirt at the ground-breaking ceremony for the new church on Bardstown Road in 1955. The church began as Fern Creek Methodist Episcopal Church South with charter members assembled in a room above the Union Store in 1913. (Courtesy of Fern Creek United Methodist Church.)

Joseph Reid, who owned the Union Store, purchased land on Fern Creek Road for the first building of Fern Creek Methodist Episcopal Church. In 1939, a merger led to the renaming of the church, and it became Fern Creek United Methodist Church. (Courtesy of Fern Creek United Methodist Church.)

In 1953, the Archbishop John A. Floersh determined that Fern Creek needed a parish. Fr. James G. Emrich became the first pastor of St. Gabriel the Archangel Church, and the first mass was celebrated in the auditorium of Fern Creek High School. (Courtesy of Archdiocese of Louisville.)

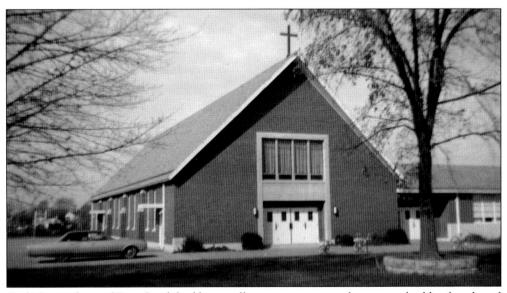

Catholic residents of Fern Creek had been collecting money over the years to build a church and school. They turned the money over to the pastor when the parish was first established in 1953. (Courtesy of Archdiocese of Louisville.)

St. Gabriel the Archangel Church and School was built on the 8.5-acre property on Bardstown Road. The building included a rectory, convent and chapel, church, bus garage, and school. (Courtesy of Archdiocese of Louisville.)

The Sisters of Charity of Nazareth lived and worshiped in the convent and chapel built on the property of St. Gabriel the Archangel. The sisters were the original staff members of St. Gabriel Catholic School. (Courtesy of Archdiocese of Louisville.)

Construction of St. Gabriel the Archangel Church and School began in 1953. The rectory was built in 1954. (Courtesy of Archdiocese of Louisville.)

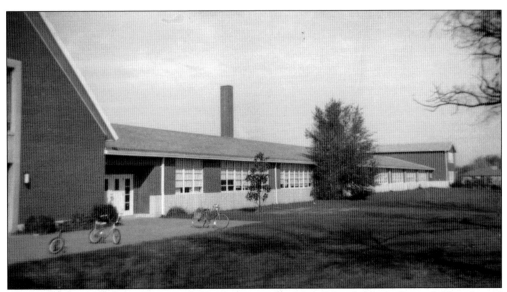

Members of the parish helped with the construction of St. Gabriel the Archangel Church and School to keep building costs at a minimum. The original church and school faced Hudson Lane. (Courtesy of Archdiocese of Louisville.)

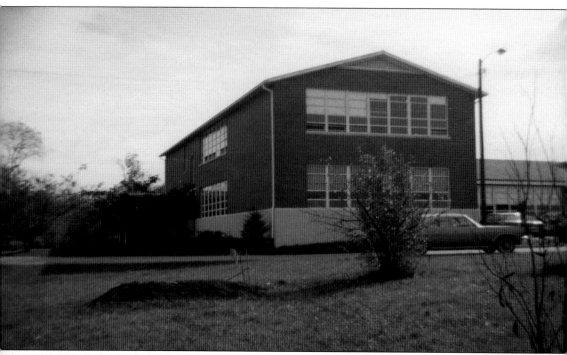

Additions to St. Gabriel the Archangel Church and School have allowed the parish to expand its reach to serve preschool through eighth grade. The former church was renovated for school classrooms and parish staff offices to support the growth of the school and congregation. (Courtesy of Archdiocese of Louisville.)

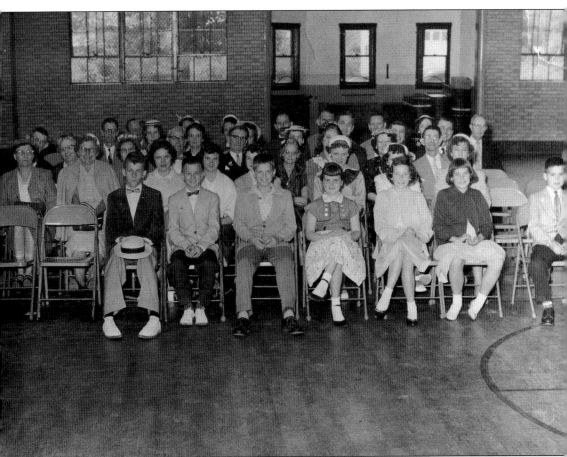

The first meeting of the Fern Creek Baptist Mission was held in the auditorium of the Fern Creek Elementary School. The mission began in October 1954 with 13 original members, but grew to 36 by the end of the year. By April 1955, membership had grown to 65 and Sunday school attendance neared 100. Midweek services drew such large crowds that space had to be rented at the Fern Creek Community Center. (Courtesy of Fern Creek Baptist Church.)

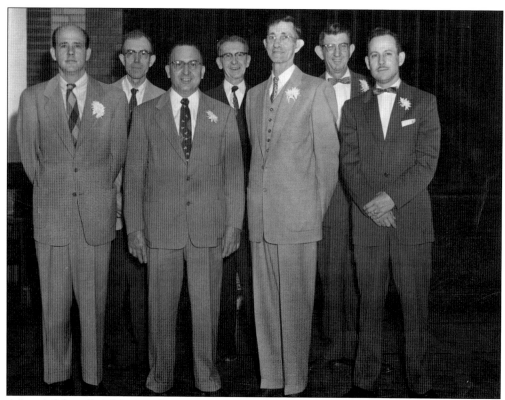

As one of the official duties of organization, Fern Creek Baptist Mission named its first deacons. The five men pictured on the right were the first deacons of the mission. (Courtesy of Fern Creek Baptist Church.)

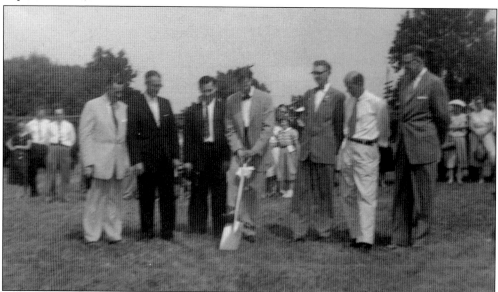

The Fern Creek Baptist Mission and its mother church, Third Avenue Baptist, purchased property at 5920 Bardstown Road in 1955 and broke ground on the first building in 1957, placing its cornerstone on the three-year anniversary of the mission. (Courtesy of Fern Creek Baptist Church.)

As a new mission, Fern Creek Baptist was led by Harold Sangster, a student from Southern Baptist Theological Seminary. His wife, Evelyn, served as director of music and began choirs with the help of her mother, who served as pianist. (Courtesy of Fern Creek Baptist Church.)

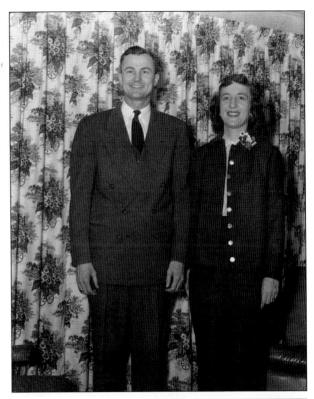

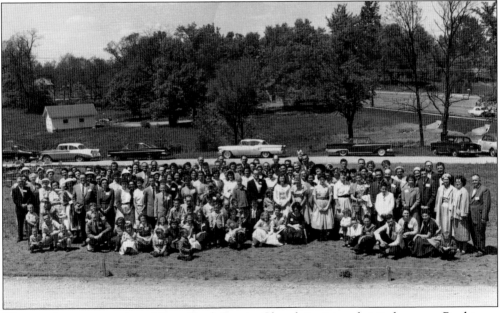

The growing congregation of Fern Creek Baptist Church is pictured at its home on Bardstown Road on Constitution Day, May 1, 1960. In addition to the 3.37 acres purchased in 1955, the church purchased an additional two acres in June 1960 with the help of Long Run Baptist Association. In October, a land swap with Standard Oil Company widened the property. (Courtesy of Fern Creek Baptist Church.)

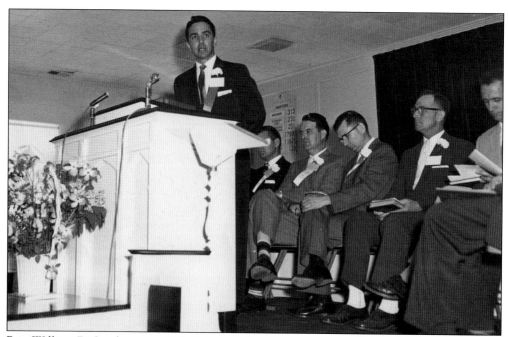

Rev. William D. Sanders was officially installed as the first pastor of Fern Creek Baptist Church on Constitution Day, May 1, 1960. Reverend Sanders was a seminary student when he delivered his first sermon at Fern Creek Baptist Mission. That sermon led to his calling as Fern Creek Baptist's first pastor. (Courtesy of Fern Creek Baptist Church.)

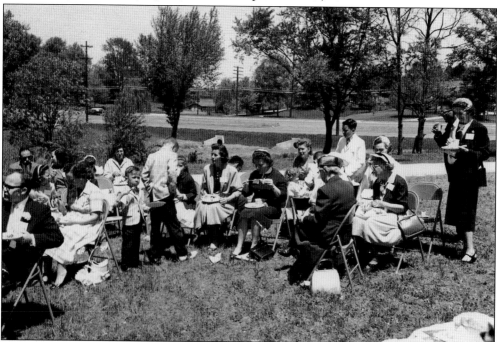

The Fern Creek Baptist Mission voted in April 1960 to become an independent church. The congregation had dinner on the grounds of the newly constituted Fern Creek Baptist Church, May 1, 1960. (Courtesy of Fern Creek Baptist Church.)

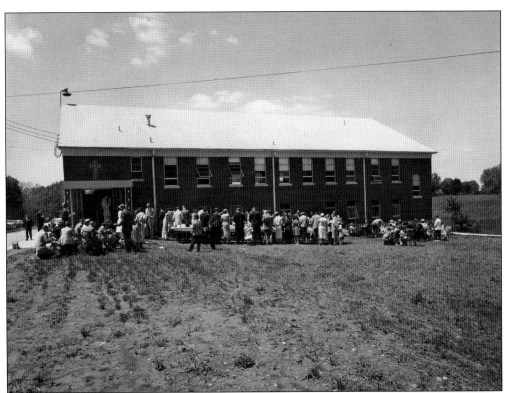

After the service officially organized Fern Creek Baptist as a church, the church held a Constitution Day dinner on the grounds on May 1, 1960. (Courtesy of Fern Creek Baptist Church.)

In 1960, the Fern Creek Community Woman's Club opened a nursery school in the Fern Creek Baptist Church building. The church later sponsored a kindergarten program. (Courtesy of Fern Creek Baptist Church.)

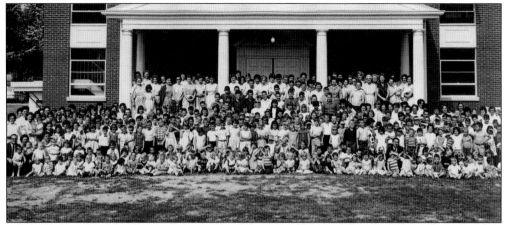

From the beginning, summer vacation Bible school for Fern Creek Baptist Mission was a success, with record numbers in attendance. (Courtesy of Fern Creek Baptist Church.).

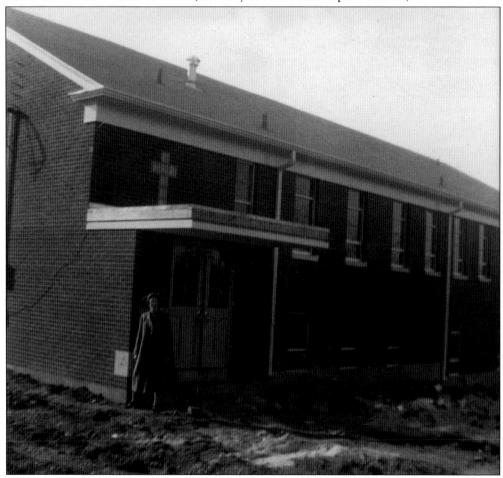

Construction of a new sanctuary began in November 1962, and the new building was dedicated September 29. At the time, Sunday school enrollment was over 600. (Courtesy of Fern Creek Baptist Church.).

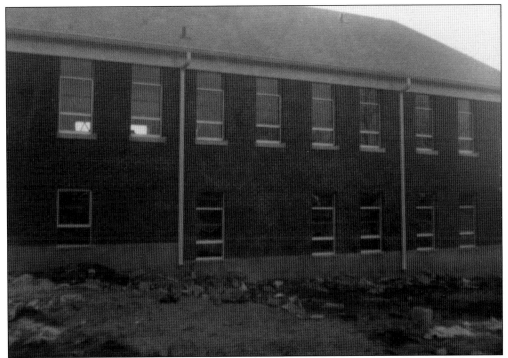

The parking lot of Fern Creek Baptist Church was paved in 1964. Although plans were made to build again in the spring of 1966, the construction never took place. (Courtesy of Fern Creek Baptist Church.)

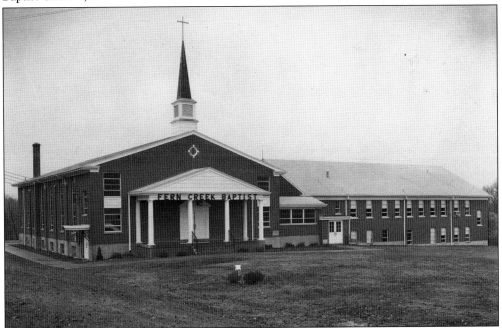

Several changes in leadership of Fern Creek Baptist Church took place in the early 1970s. After an unsettled period, the church experienced exceptional growth. (Courtesy of Fern Creek Baptist Church.)

A church library was installed under the leadership of the Rev. Don Atkinson, who came to Fern Creek Baptist Church in 1971. (Courtesy of Fern Creek Baptist Church).

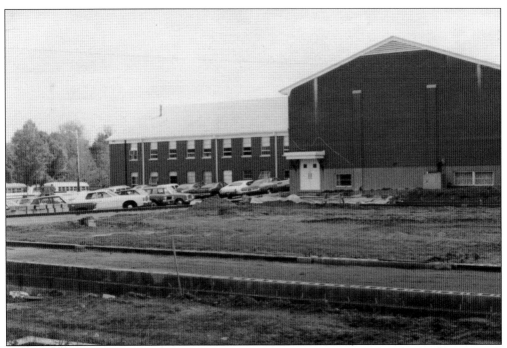

In 1974, under the leadership of Reverend Atkinson, Fern Creek Baptist Church voted to construct a Christian Life Center complete with a gym, classrooms, and a kitchen. Construction on the building began in 1975. (Courtesy of Fern Creek Baptist Church.)

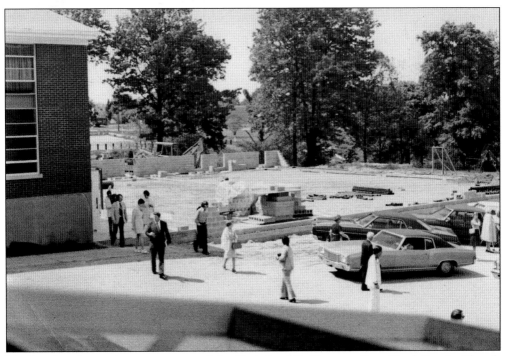

Membership during the construction of the Christian Life Center at Fern Creek Baptist Church rose to 887 in 1975. (Courtesy of Fern Creek Baptist Church.)

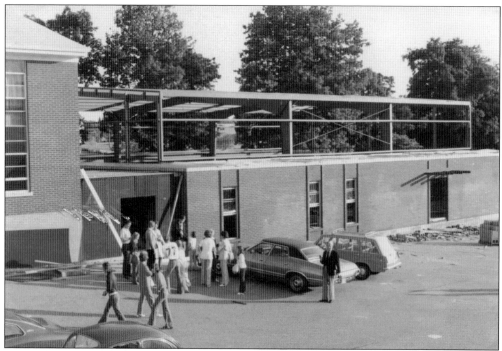

The members of Fern Creek Baptist Church saved so much on the construction of the Christian Life Center in 1975 that they were able to add new drapes, paint, and carpet on the interior in 1976 without adding to the cost. (Courtesy of Fern Creek Baptist Church.)

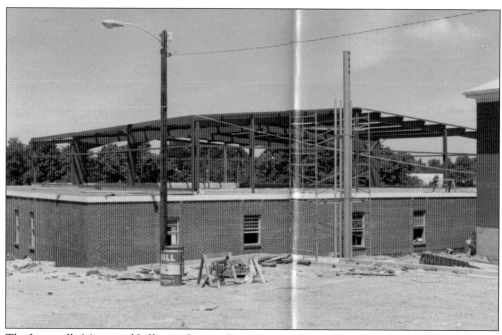

The Louisville Metro and Jefferson County Department of Health used the Christian Life Center of Fern Creek Baptist Church for monthly well-baby exams and as an immunization clinic upon its completion in 1976. (Courtesy of Fern Creek Baptist Church.)

The building of
the Christian Life
Center at Fern
Creek Baptist
Church spurred
education and
recreation programs
for youth who enjoy
using the church
grounds for activities
and fellowship.
(Courtesy of Fern
Creek Baptist
Church.)

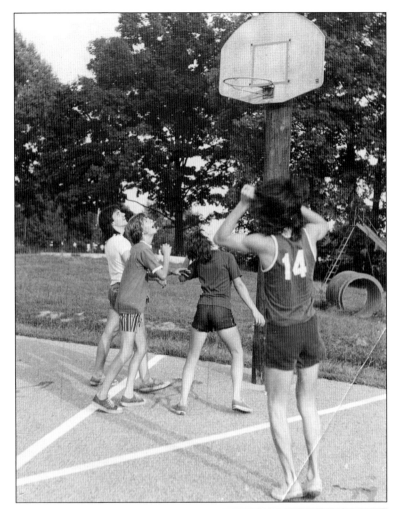

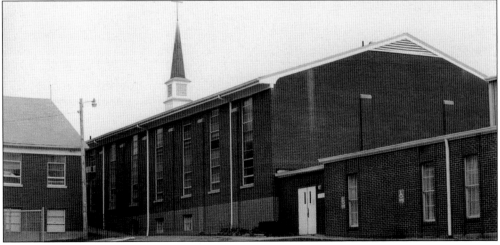

The view of the rear of Fern Creek Baptist Church after the completion of the Christian Life
Center in 1975 remained the same until 2010. (Courtesy of Fern Creek Baptist Church.)

In 1958, St. Stephen Lutheran Church applied to the synod for a mission developer to organize its own church. The original congregation met at Fern Creek Community Center from 1956 until the dedication of their new building in 1963. (Courtesy of St. Stephen Lutheran Church.)

St. Stephen Lutheran Church began in 1956 as a mission of Trinity Lutheran Church, meeting at the Fern Creek Community Center. (Courtesy of St. Stephen Lutheran Church.)

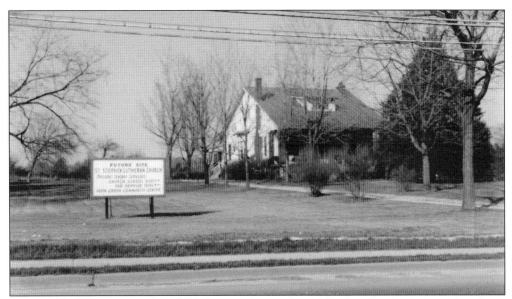

In 1959, the congregation purchased seven acres to build St. Stephen Lutheran Church on Bardstown Road. The home on the property originally served as a parsonage and was later sold. (Courtesy of St. Stephen Lutheran Church.)

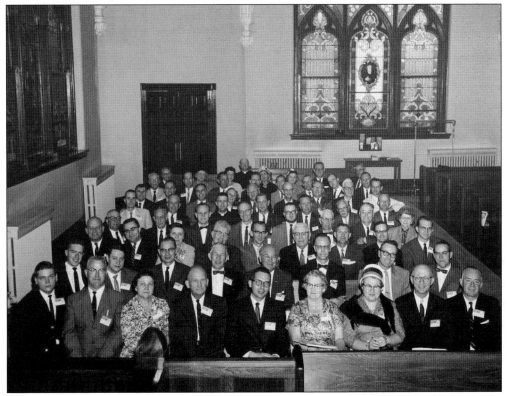

St. Stephen Lutheran Church began as Trinity Chapel, a mission of Trinity Lutheran Church in 1956. By 1960, St. Stephen Lutheran Church had formed with 73 charter members. (Courtesy of St. Stephen Lutheran Church.)

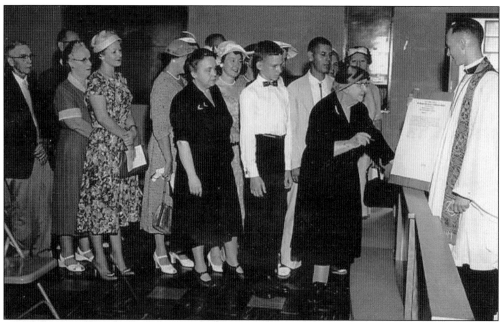

Pastor Robert L. Hauss served as the developer of St. Stephen Lutheran Church beginning in 1959 and served less than two years. (Courtesy of St. Stephen Lutheran Church.)

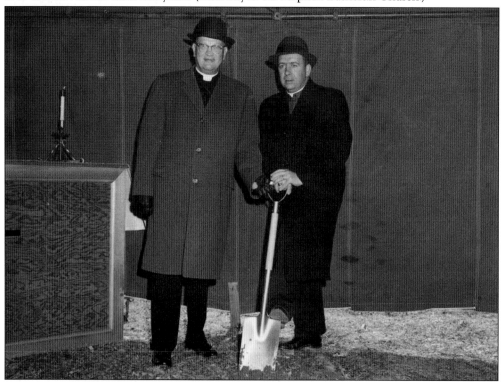

The Rev. Gerald Bush and Pastor Albert F. Nyland III led the ground-breaking ceremonies for the first church building in December 1962. Pastor Nyland served the church until 1964. (Courtesy of St. Stephen Lutheran Church.)

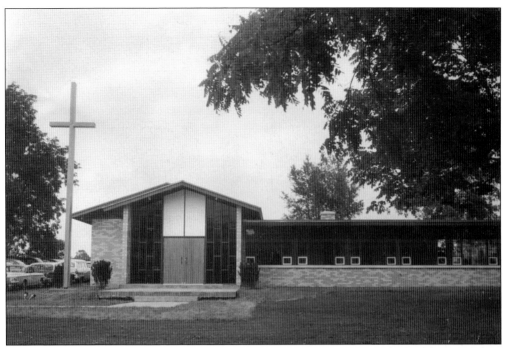

St. Stephen Lutheran Church's new building was complete in 1963. The building was then dedicated in July. (Courtesy of St. Stephen Lutheran Church.)

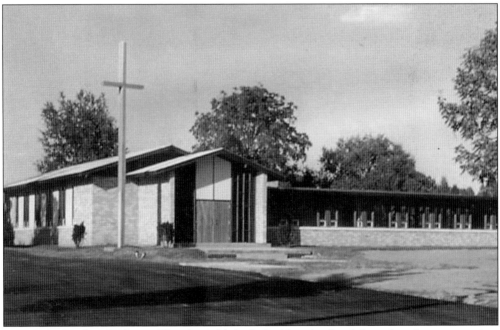

In 1981, St. Stephen Lutheran Church established a building fund and drew plans for an expansion. The ground breaking for an enlarged Narthex, Fellowship Hall, classrooms, and offices took place in 1986, and the building was dedicated in 1987. (Courtesy of St. Stephen Lutheran Church.)

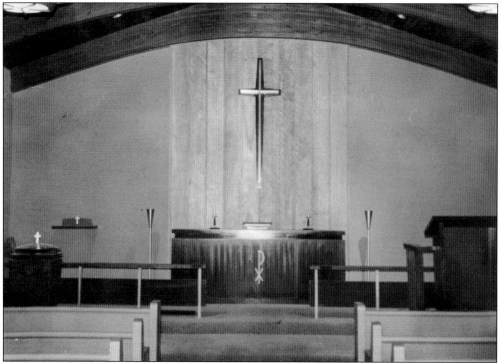

In 1968, St. Stephen Lutheran Church chose to become self-sufficient in regard to salary aid from the Lutheran Church in America's Board of American Missions. They sold the parsonage and established a housing allowance for the pastor. (Courtesy of St. Stephen Lutheran Church.)

The Reverend Thomas D. Swasko was called to serve St. Stephen Lutheran Church in 1973. He retired after 34 years of service. (Courtesy of St. Stephen Lutheran Church.)

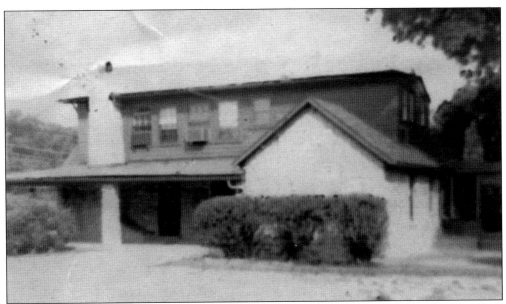

Eastland Church of Christ officially began in 1962 when it purchased this property at 5017 Bardstown Road. Previously, in 1958, the members of two families gathered for worship in the home of Jack Reeb and later moved to the Hikes Graded School in Buechel. This house was remodeled to accommodate a large meeting room in the front of the house, while rooms in the rear, on the second floor, and in the lower level were used for classes. (Courtesy of Eastland Church of Christ.)

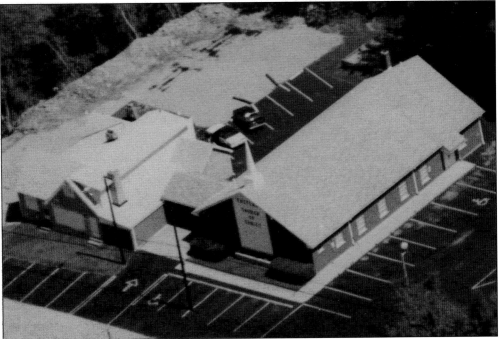

Additions to Eastland Church of Christ at 5017 Bardstown Road were added in 1968, 1979, and 1987, as weekly church attendance more than doubled between 1964 and 1979. (Courtesy of Eastland Church of Christ.)

Eastland Church of Christ moved to its current location in 1989 after additional growth indicated the need for more space. The building was complete in 1995, and additional classrooms were added in 2003. (Courtesy of Eastland Church of Christ.)

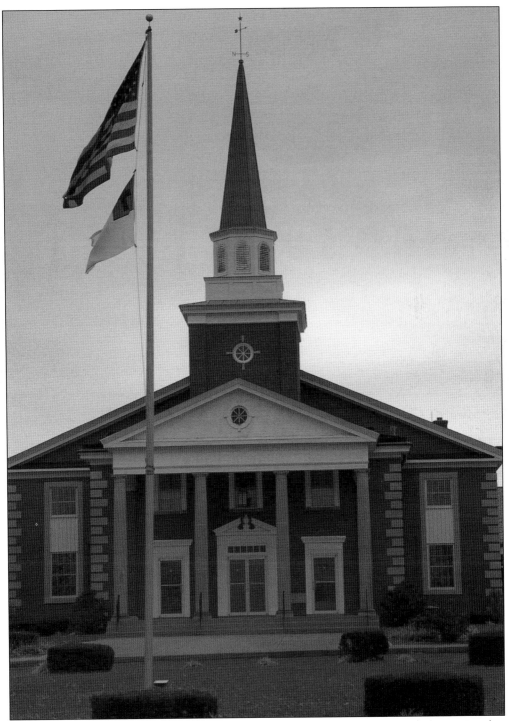

Cedar Creek Baptist Church was built at the corner of Cedar Creek Road and Bardstown Road in 1850. Its original members came from Chenoweth Run Baptist, which started in 1792. The name was changed in 1846 when the church moved. Land for Cedar Creek Baptist Church was donated by William Cralle in 1849, and the building was completed in 1850. (Author's collection.)

CEDAR CREEK BAPTIST CHURCH

First named Chenoweth Run, church formally organized June 16, 1792, about 12 mi. S. E. of Louisville. Log church built 1798 on land given by William Fleming to Moses Tyler, trustee. Moved to this community after changing name to Cedar Creek, 1846. Present church completed in 1962. Congregation continuously active since 1792 organization.

Presented by Cedar Creek Baptist Church

1991 KENTUCKY HISTORICAL SOCIETY KENTUCKY DEPARTMENT OF HIGHWAYS 1891

Howard Wheeler, a lifelong member of Cedar Creek Baptist Church and local historian, helped the church obtain its designation on the list of Kentucky state historical markers. This marker was installed at the church entrance. (Author's collection.)

Four

TRANSPORTATION

Bardstown Road was known by many names, including the Stage Road, Bardstown Pike, and Jackson Highway. A main thoroughfare from Louisville to Bardstown, part of the road was once a buffalo trail that underwent various improvements as the modes of transportation changed. Inns and stagecoach stops sprung up along the route between the two towns. (Courtesy of Bonnie H. Fritschner.)

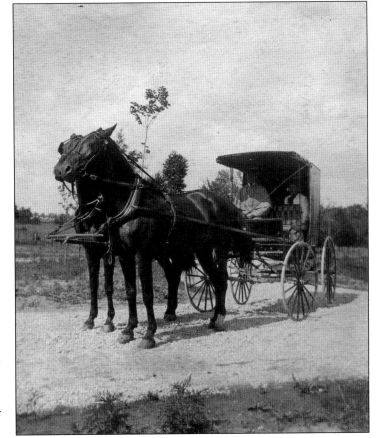

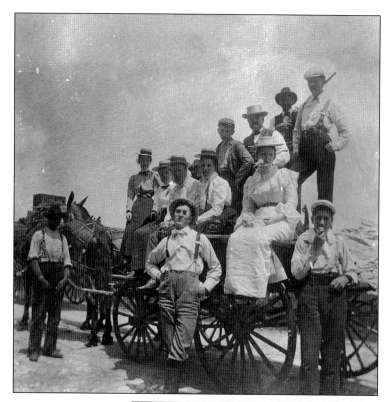

When land was first granted along Bardstown Road, it was little more than a buffalo trace. It was barely fit for a wagon, one of the earliest forms of transportation along the route. (Courtesy of Bonnie H. Fritschner.)

When the Louisville-Bardstown Turnpike was chartered in 1831, and the Louisville Turnpike Company began construction of a macadamized road in 1832, it became easier to maneuver horse-drawn wagons along the route. (Courtesy of Bonnie H. Fritschner.)

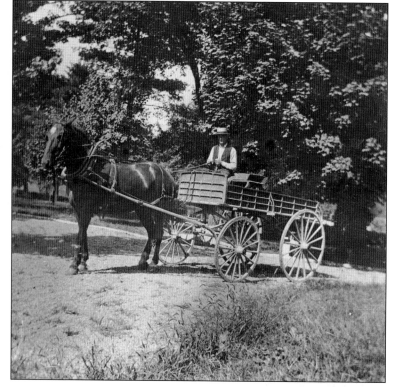

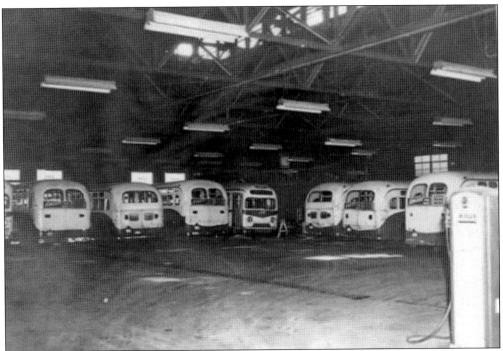

Electric interurban cars were introduced in Louisville in 1893 and construction on the interurban lines connecting downtown to the outlying parts of Jefferson County began in 1903 with the incorporation of the Louisville and Interurban Railroad Company. In 1908, the line was installed along Bardstown Road to Fern Creek and a terminal and freight house was added. Blue Motor Coach began operating a bus line using the same terminal in Fern Creek. (Courtesy of Kentucky Historical Society.)

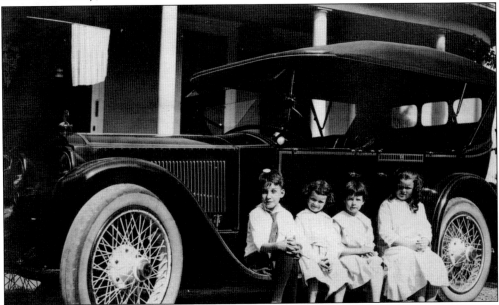

The Long family children, including Irving Miles and Evelyn Long, enjoyed Sunday afternoon drives in Lee Miles's car. (Courtesy of Bonnie H. Fritschner.)

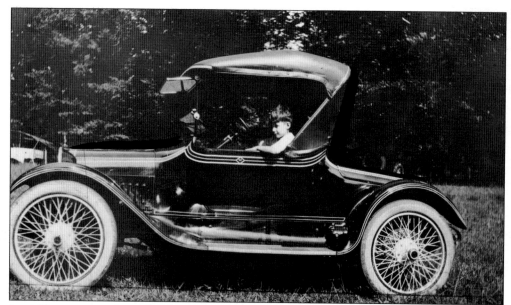

Lee Miles, vice president of Longest Brothers, later owned Yellow Taxicab and Transfer Company in Louisville. Miles's car was personalized with pinstripes and the initial "M." (Courtesy of Bonnie H. Fritschner.)

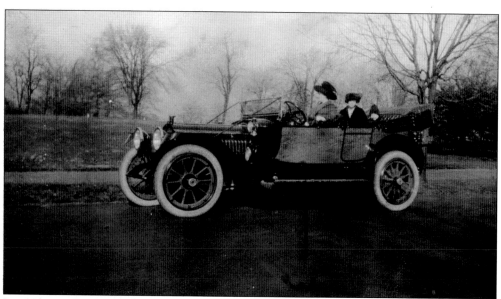

Lee Miles met his future wife, the widow Florence Long Taggart, when he taught her how to drive an electric car she purchased from him in 1906. (Courtesy of Bonnie H. Fritschner.)

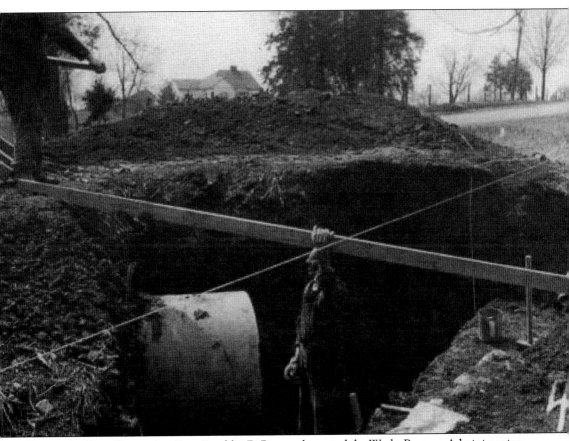

During the Great Depression, Pres. Franklin D. Roosevelt created the Works Progress Administration (WPA) to give work relief to millions. In Kentucky, approximately 73,000 were employed by the program between 1936 and 1938. WPA workers improved drainage on Beulah Church Road by installing a culvert to allow water to drain under the road. (Courtesy of Goodman-Paxton Photographic Collection PA64M1, Kentucky Special Collections Research Center.)

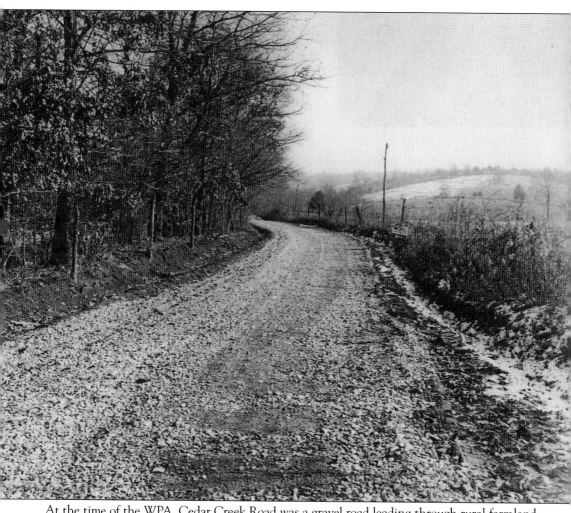

At the time of the WPA, Cedar Creek Road was a gravel road leading through rural farmland. (Courtesy of Goodman-Paxton Photographic Collection PA64M1, Kentucky Special Collections Research Center.)

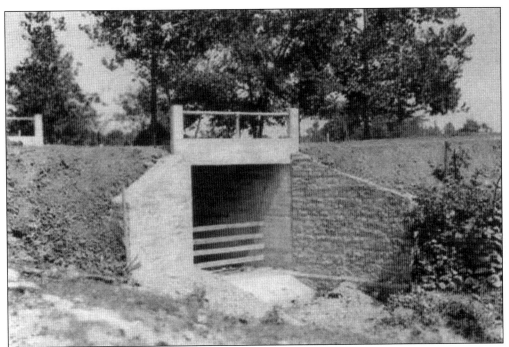

This box culvert installed by workers from the WPA on Seatonville Road formed a bridge over Floyd's Fork. (Courtesy of Goodman-Paxton Photographic Collection PA64M1, Kentucky Special Collections Research Center.)

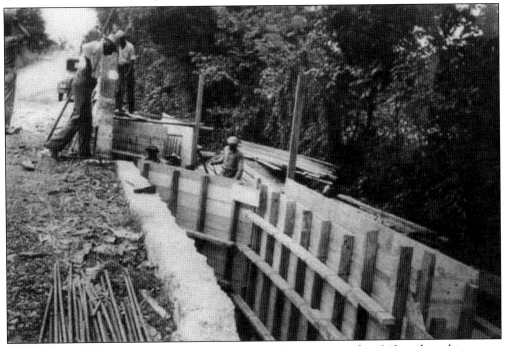

The WPA worked on or constructed 62 bridges in Jefferson County by 1940, such as this one on Seatonville Road. (Courtesy of Goodman-Paxton Photographic Collection PA64M1, Kentucky Special Collections Research Center.)

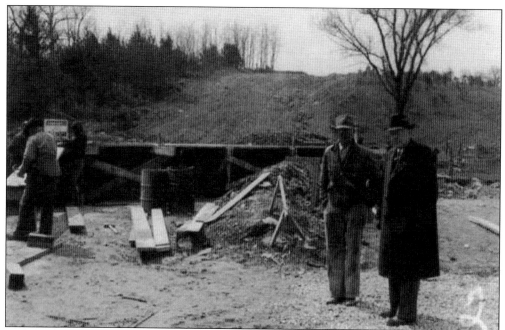

Many of the new roads constructed by the WPA were built in rural areas where travel had previously been limited. In Jefferson County, approximately 348 miles of roads and sidewalks were paved by the WPA by 1940. (Courtesy of Goodman-Paxton Photographic Collection PA64M1, Kentucky Special Collections Research Center.)

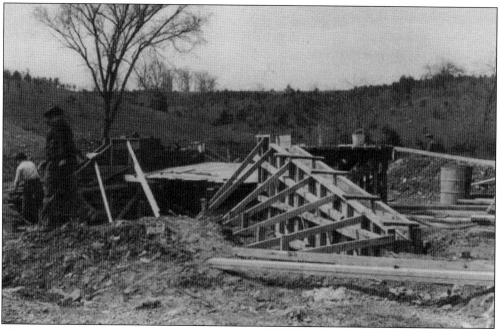

The construction and improvement of roads, bridges, drainage ditches, and sewers were among the federal agency's many projects. The new roads connected rural areas across the state. (Courtesy of Goodman-Paxton Photographic Collection PA64M1, Kentucky Special Collections Research Center.)

Automobiles and paved roads soon made the interurban cars obsolete, and service was ended in 1933. By 1958, one million Kentuckians owned motor vehicles. (Courtesy of Kathy Fraley.)

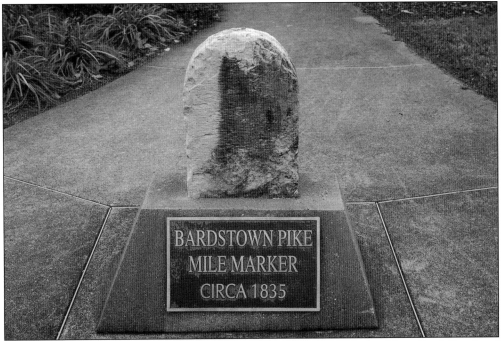

The turnaround loop for the interurban track was located at the corner of Fern Creek Road and Bardstown Road. This was also the location of the terminal and freight house. The site is marked by a mile post cut from stone. (Author's collection.)

AN EARLY TURNPIKE

The Bardstown and Louisville Turnpike Co., chartered by Ky. Legislature, 1831, was capitalized at $130,000, increased to $200,000. Shares owned half by individuals, half by state. Turnpike completed July 1, 1838 at cost of $203,598. Length of road 29 miles; width 60 feet cleared with 40 graded. Tolls collected during year ending Oct. 1841 amounted to $9,755.

2000 KENTUCKY HISTORICAL SOCIETY KENTUCKY DEPARTMENT OF HIGHWAYS 1022

The Kentucky state historical marker for the Bardstown-Louisville Turnpike was installed at Mount Washington Baptist Church at the intersection of Highway 31 E and Highway 44 in Mount Washington, Kentucky. (Author's collection.)

MILE STONES, ca. 1835

Along the early turnpikes the law required mile posts. Some were cut from stone and some cast in iron. They showed the distance to each end of the turnpike. Typical of the stone markers are 14 along the east side of the present highway, at their approximate initial locations beside the old Bardstown and Louisville Turnpike. See over.

Presented by the City of Mt. Washington
and the Bullitt County Fiscal Court
2000 KENTUCKY HISTORICAL SOCIETY KENTUCKY DEPARTMENT OF HIGHWAYS 1022

The law required mile posts to be installed showing the distance to each end of the turnpike. The markers were called mile stones because some were originally cut from stone. (Author's collection.)

110

Five

COMMUNITY

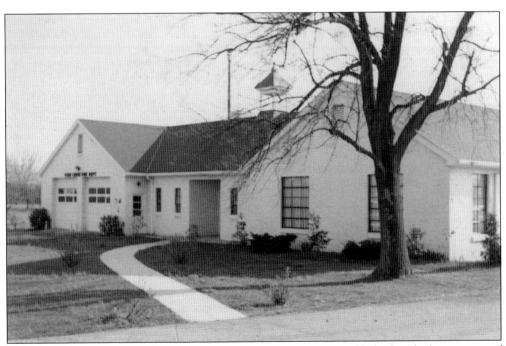

Incorporated in 1948, the Fern Creek Community Club was established with the purpose of encouraging projects that would benefit the community. The community club founded the first post office in Fern Creek. Mrs. Martin Schmidt donated the property at the corner of Fern Creek Road and Bardstown Road for a community recreation house and firehouse, which became the Fern Creek Community Center and Fire Station No. 1 in 1955. The location was the former site of the Union Store, which burned in 1940. (Courtesy of St. Stephen Lutheran Church).

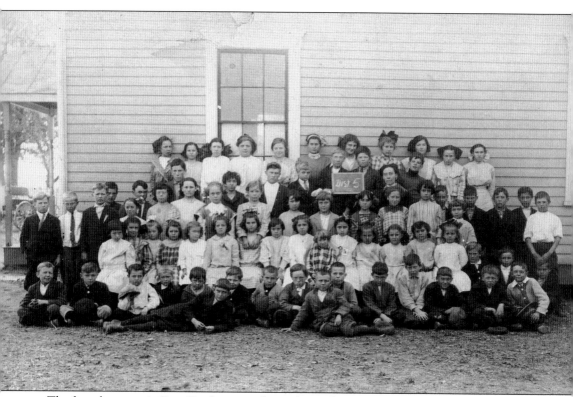

The first classroom in Fern Creek was in a house located at a stagecoach stop on Bardstown Road in the late 1800s. The first public schoolhouse was a frame building with two rooms, which began in the early 1900s and remained in operation until the new school was built in 1923. (Courtesy of Fern Creek Alumni Association).

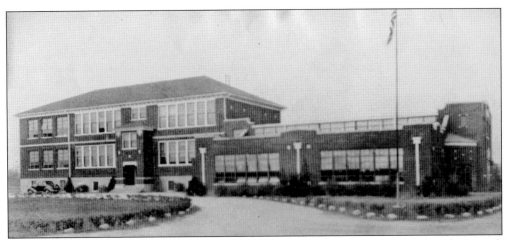

Fern Creek High School was built next to the original school, which became Fern Creek Elementary. Over the years, the school has been extensively renovated and remodeled to make space for additional classrooms and a gym, a library, and a science lab. (Courtesy of Fern Creek Alumni Association.)

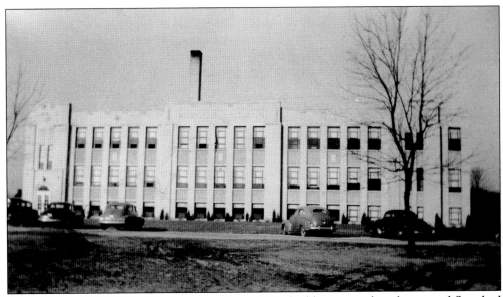

By 1941, Fern Creek School had outgrown its existing building, even though a second floor had been added to the original building and a gym and other classrooms had been constructed to accommodate the growing numbers. The school became so crowded in the 1960s, it offered double sessions, with the high school attending from 7:00 a.m. to 1:35 p.m. and junior high from 1:40 p.m. to 8:00 p.m. A new elementary school was built to accommodate the growth in the area. (Courtesy of Fern Creek Alumni Association.)

The Fern Creek High School Band was first organized in 1939 under the leadership of band director Vivian Taylor. In 1941, the band played at the Kentucky State Fair for the first time. In 1957, the band marched in the Mardi Gras parade and went on to march in the Cotton Carnival parade in Memphis in 1961. (Courtesy of Fern Creek Alumni Association.)

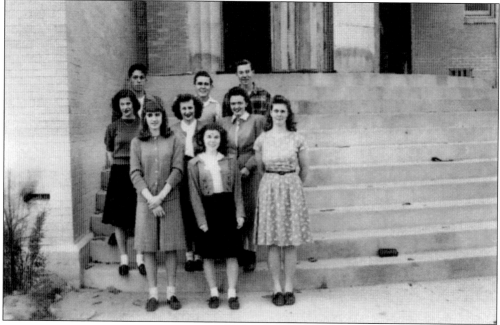

By 1947, in addition to numerous boys' and girls' sports, Fern Creek High School offered a variety of clubs and activities, such as future homemakers, glee club, Spanish club, band, senior play, F club, beta club, library club, home economics club, girls' reserves, dramatic club, alpha club, 4-H club, Latin club, annual staff, and the *Creeker* newspaper staff. (Courtesy of Kathy Fraley.)

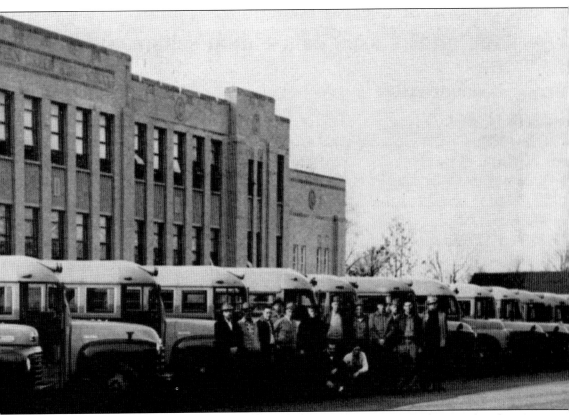

The number of buses parked in front of Fern Creek High School in this 1953 photograph indicate the growth in the area. Expansion into the suburbs was spurred by the construction of General Electric Appliance Park and Ford Motor Company. (Courtesy of Jefferson County Public Schools Archives and Records Center.)

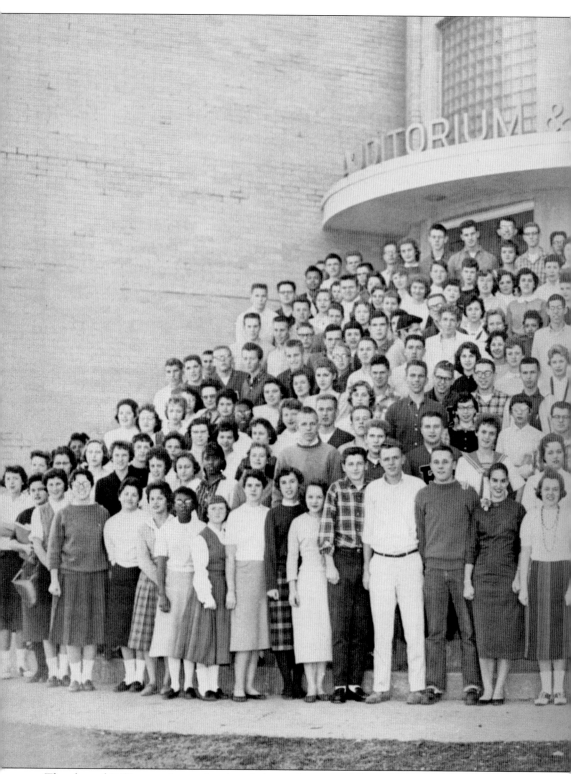

The class of 1959 was so large, they barely fit on the steps of the auditorium of Fern Creek High

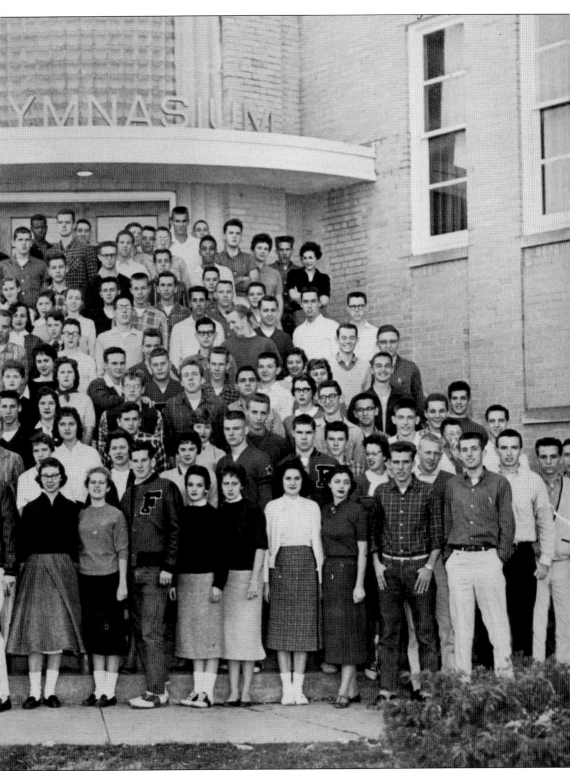

School. (Courtesy of Jefferson County Public Schools Archives and Records Center.)

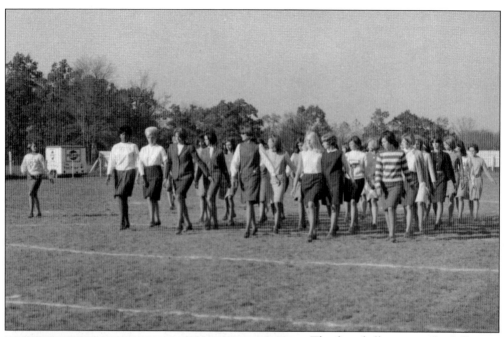

The first drill corps in the Jefferson County Public School System was established at Fern Creek High School in 1955. The drill corps performed during sports games and even marched in the 1960 derby parade. School clubs and organizations provided stability during an otherwise tumultuous time. (Courtesy of Kathy Fraley.)

By 1967, enrollment at Fern Creek High School had reached 2,320. A new wing was planned but not complete until 1974. Moore High School was built to accommodate the population growth, but construction was not finished until 1969. Despite the overcrowding, Fern Creek High School's class of 1967 carried on, voting Donald Dorwart and Kathy Martin "most likely to succeed." (Courtesy of Kathy Fraley.)

Kathy Martin and John Fraley attended Fern Creek High School in the 1960s at a time when the school experienced record growth. The school provided focus and contributed to the growth of Fern Creek as a community. (Courtesy of Kathy Fraley.)

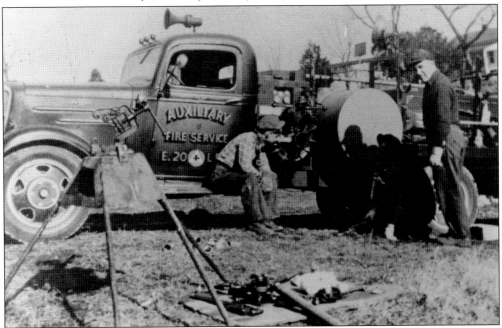

The first fire truck for the Fern Creek Volunteer Fire Department came solely from contributions and donations. The City of Louisville contributed the body onto which the first pump, purchased from advances given by members of the original Fern Creek Community Club, was mounted. (Courtesy of Fern Creek Fire Department.)

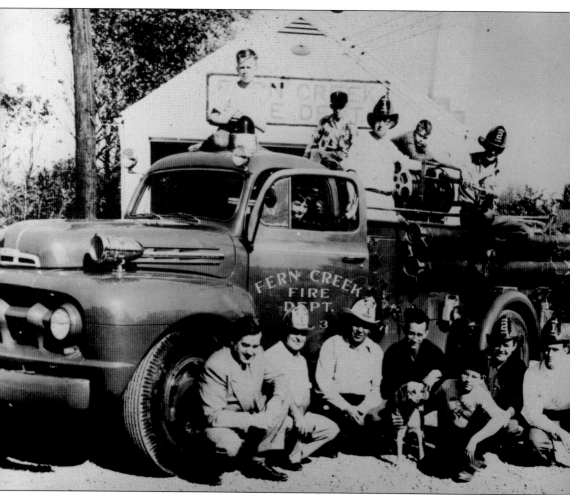

The crew of the Fern Creek Fire Department is pictured here in 1951 at the original Fern Creek Firehouse, built in 1946 at the corner of Fern Creek Road and Ferndale Road. The fire department incorporated in 1948. A high school firefighter program began in 1951 after a field fire near the high school. (Courtesy of Fern Creek Fire Department.)

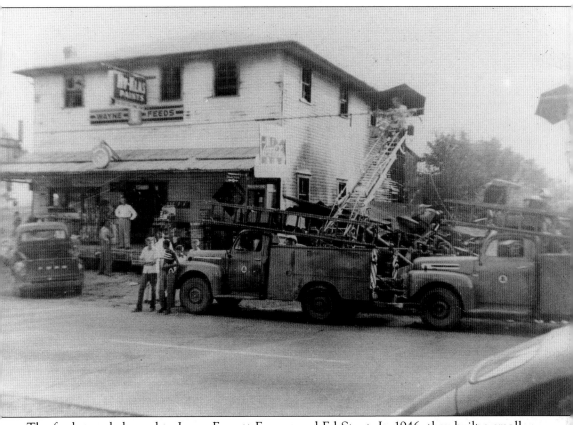

The feed store belonged to James Everett Farmer and Ed Stout. In 1946, they built a small building at the rear of this property, located at Fern Creek Road and Ferndale Road, which served as the first firehouse of the Fern Creek Volunteer Fire Department. (Courtesy of Fern Creek Fire Department.)

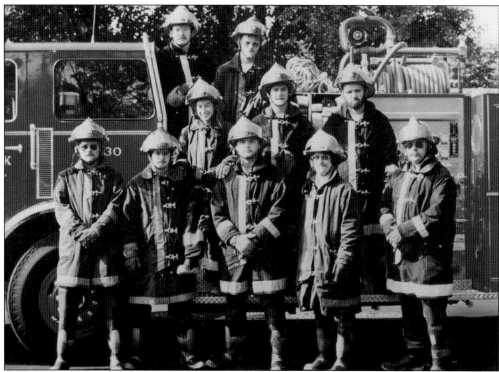

The Fern Creek Fire Department experienced tremendous growth during the 1980s with the purchase of the property at Brush Run Road and Routt Road, construction and dedication of Fern Creek Fire Station No. 3, and the expansion of Fern Creek Fire Station No. 2 and establishment of the Jefferson County Fire Training Academy. (Courtesy of Fern Creek Fire Department.)

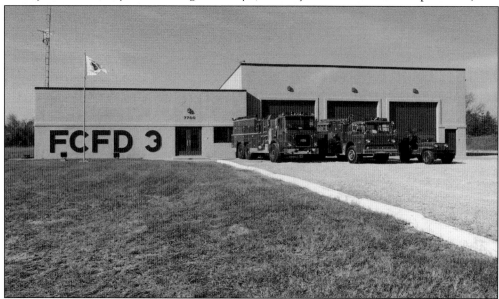

Fern Creek Fire Station No. 3 is an energy efficient design, constructed of polystyrene foam walls reinforced with steel and covered in sprayed-on concrete. A 70,000-gallon cistern supplies water for rural firefighting tanker shuttle operations. (Courtesy of Fern Creek Fire Department.)

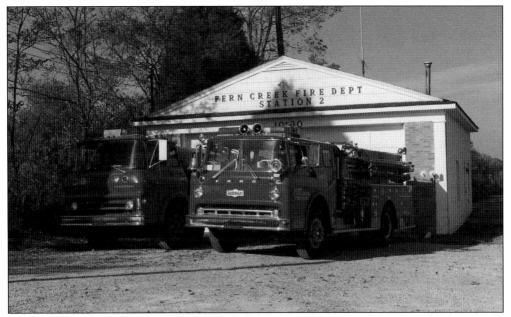

Property in the 9400 block of Bardstown Road, between the old road and the new road, was purchased in 1988, and an agreement made with the state highway department in order to build Fern Creek Fire Station No. 3. The new station serves the residents of Glenmary subdivision and the surrounding neighborhoods that have developed since the completion of the Snyder Freeway. (Courtesy of Fern Creek Fire Department.)

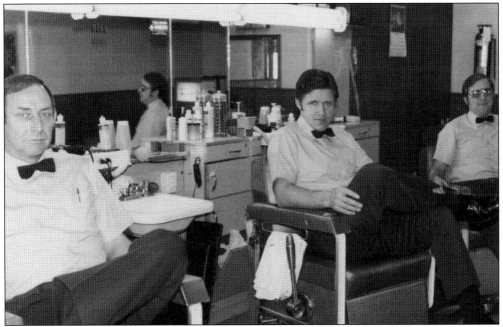

Fern Creek Barber Shop was founded in 1959 by Earl Shepperson and is one of the few remaining businesses of its kind from that era still in operation today. Shepperson is pictured here at left with fellow barbers William R. Chelf (center) and Marvin Bradshaw around 1978. (Courtesy of Steve Roberts.)

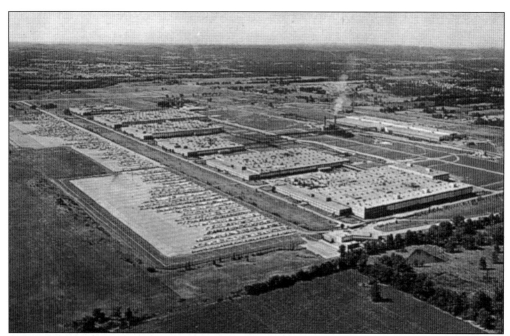

General Electric Appliance Park was built in 1952 on 700 acres of land in Buechel, in southeastern Jefferson County, northwest of Fern Creek. (Courtesy of the University of Kentucky Special Collections Research Center.)

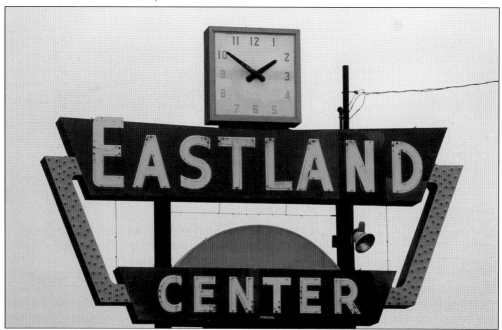

The 1950s brought about many changes in rural Jefferson County. General Electric and Ford built manufacturing plants in the southeastern part of the county, and the Watterson Expressway was completed in 1958, setting the stage for shopping centers like Eastland Center (at 4680 Bardstown Road) and others that sprouted along busy thoroughfares like Bardstown Road. (Author's collection.)

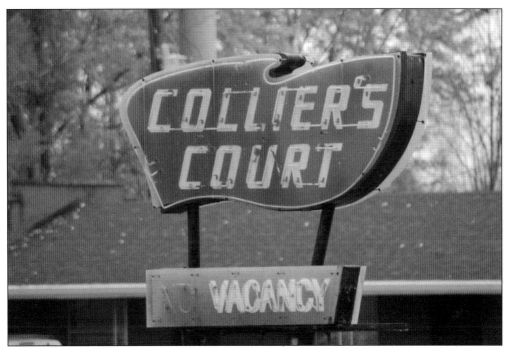

When the Brown Suburban Hotel opened on Bardstown Road near the Watterson Expressway in 1956, it opened the door for suburban motels such as Collier's Court, located at 4812 Bardstown Road. (Author's collection.)

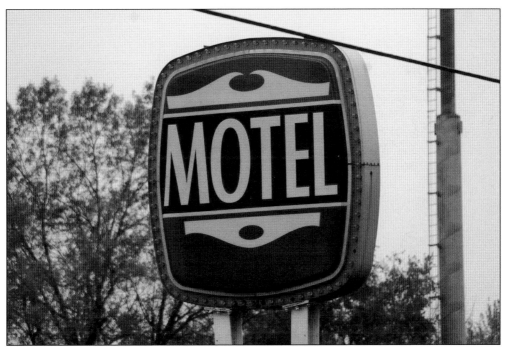

Motel business in Louisville increased with the opening of a commercial airport at Standiford Field in the 1940s and the construction of the Watterson Expressway in the 1950s. (Author's collection.)

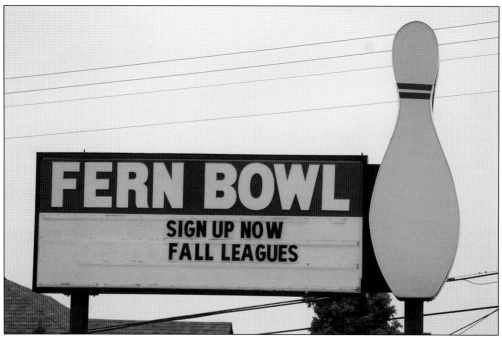

The changes in the 1950s were not just evident in the landscape. For the first time, people had both money and time to spend on leisure as the shift occurred toward manufacturing and factory jobs away from agriculture. Bowling grew in popularity in the 1950s, and Fern Bowl (at 5518 Bardstown Road) offered people a way to spend their free time. (Author's collection.)

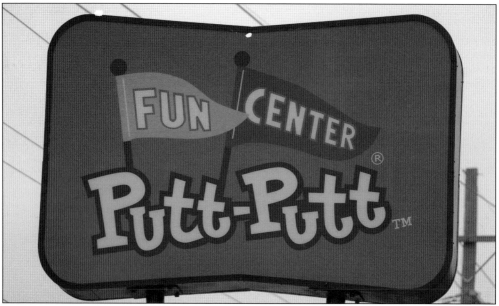

As the suburbs expanded, more businesses opened along Bardstown Road. The Showcase Cinemas opened on Bardstown Road just south of the Watterson Expressway in 1965 and people continued to seek other forms of entertainment and recreation like miniature golf at Putt-Putt Fun Center at 5720 Bardstown Road. (Author's collection.)

BIBLIOGRAPHY

Allison, Young E. *The City of Louisville and a Glimpse of Kentucky*. Louisville: Committee on Industrial and Commercial Improvement of the Louisville Board of Trade, 1887.

A Brief History of the Fern Creek Fire Department. Louisville: The Fern Creek Fire Department, 2013.

Fern Creek: Lore and Legacy, 200 Years. Fern Creek: Fern Creek Woman's Club, 1976.

History of the Ohio Falls Cities and Their Counties. Cleveland: L.A. Williams Company, 1882.

Johnston, J.S. *Memorial History of Louisville from its First Settlement to the Year 1896*. Chicago: American Biographical Publishing Company, 1898.

Kleber, John E. *The Encyclopedia of Louisville*. Lexington: University Press of Kentucky, 2001.

——————. *The Kentucky Encyclopedia*. Lexington: University Press of Kentucky, 1992.

Multiple Resource Nomination to the National Register of Historic Places. Washington, DC: National Register of Historic Places, 1972–1979.

Nomination forms and registration forms. Washington, DC: National Register of Historic Places.

A Place in Time: The Story of Louisville's Neighborhoods. Louisville: The Courier-Journal, 1989.

Popham, Linda, ed. *Fern Creek Baptist Church: Celebrating Sixty Years*. Louisville: Fern Creek Baptist Church, 2014.

Taylor, Carol. *A Rare Vision: The History of Fern Creek Traditional High School*. Louisville: Fern Creek Traditional High School, 2005.

DISCOVER THOUSANDS OF LOCAL HISTORY BOOKS FEATURING MILLIONS OF VINTAGE IMAGES

Arcadia Publishing, the leading local history publisher in the United States, is committed to making history accessible and meaningful through publishing books that celebrate and preserve the heritage of America's people and places.

Find more books like this at
www.arcadiapublishing.com

Search for your hometown history, your old stomping grounds, and even your favorite sports team.